This Anguished World of Shadows

Georges Rouault's

MISERERE ET GUERRE

This Anguished World of Shadows

HOLLY FLORA & SOO YUN KANG

Museum of Biblical Art, New York,
in association with D Giles Limited, London

This catalog accompanies the exhibition *This Anguished World of Shadows: Georges Rouault's Miserere et Guerre*, on display at the Museum of Biblical Art, March 30–May 28, 2006

ON THE FRONT COVER Georges Rouault, *Lonely, in this life of pitfalls and malice.* (detail)
ON THE BACK COVER Georges Rouault, *Who does not put on make-up?*

© 2006 Museum of Biblical Art

All rights reserved

First published jointly in 2006 by GILES,
an imprint of D Giles Limited
57 Abingdon Road, London, W8 6AN, UK
www.gilesltd.com
and
Museum of Biblical Art
1865 Broadway (at 61st Street)
New York, NY 10023
USA
Phone: 212-408-1500
Fax: 212-408-1292
info@mobia.org
www.mobia.org

Library of Congress Cataloging-in-Publication
Data
Flora, Holly.
 This anguished world of shadows : Georges
Rouault's Miserere et guerre / Holly Flora and
Soo Yun Kang.
 p. cm.
 Summary: "A catalog produced by the Museum
of Biblical Art to accompany This anguished
world of shadows: Georges Rouault's Miserere et
guerre (March 30–May 28, 2006). Includes three
scholarly essays and an extensive bibliography,
as well as reproductions of all 58 prints from the
series, two additional prints, and three paintings,
accompanied by biblical quotations."–Provided
by publisher.
Includes bibliographical references.
ISBN 0-9777839-0-1 (alk. paper)
ISBN 1-904832-25-3 (alk. cloth)

 1. Rouault, Georges, 1871–1958. Miserere–
Exhibitions. 2. Christian art and symbolism–
Exhibitions. 3. War in art–Exhibitions. I. Kang,
Soo Yun, 1964– . II. Museum of Biblical Art.
III. Title.
 NE2049.5.R68A7 2006
 769.92–dc22
 2006001877

The exhibition was curated by Holly Flora,
Curator of Exhibitions, Museum of Biblical Art.

EDITOR Holly Flora
PROJECT MANAGER Ute Keyes
PROOFREADERS Megan R. Whitman and
Moria Johnston
CONTRIBUTING EDITOR Kenneth Benson
CATALOG DESIGN Kara Van Woerden
PHOTOGRAPHY Gina Fuentes Walker
EXHIBITION DESIGN Barbara Suhr

Printed in Italy

*All biblical quotations are taken from the King
James version of the Bible*

All measurements are in inches, height x width

*This Anguished World of Shadows:
Georges Rouault's Miserere et Guerre*
has been underwritten by Howard and
Roberta Ahmanson.

The *Miserere* series is on long-term loan to
MOBIA from the collection of Robert and
Sandra Bowden and will be traveled nationally.

MUSEUM OF BIBLICAL ART
MOBIA

g
GILES

FROM THE SPONSORS

PERHAPS Georges Rouault's understanding of the importance of suffering began in 1871 when he was born in a Parisian suburb during the Franco-Prussian War. Whatever his source, Rouault grasped that suffering is magnified by loneliness. To hurt and to be alone with that hurt can prove unbearable. In war, men and women die in violence, separated from those who love them. The innocent — children, women, the aged — die the same way. In *Miserere et Guerre*, Rouault attempts both to uncover that aloneness and to give it dignity and suggest its relief. We suffer; God suffers with us. The psalmist says that the reproaches that fall on God fall on us. St. Paul tells us that it is through Christ's suffering that we are healed. Though Rouault embraced the Christian mystery of the redemptive power of suffering, he was compelled to pursue its meaning. Nor is it necessary to share his faith to affirm his quest. At a time when the violence of war and strife are spreading death and destruction across the globe, we all need to ponder the meaning of suffering, not only for individuals, but for the human community as a whole. *This Anguished World of Shadows: Georges Rouault's Miserere et Guerre* provides that opportunity. In pondering suffering, we also reflect on what it means to be truly human. It is our privilege to be part of that endeavor.

HOWARD AND ROBERTA AHMANSON
Irvine, California
January 2006

ROUAULT AT THE MUSEUM OF BIBLICAL ART

ONE of the objectives of the Museum of Biblical Art is to engage in a dialogue about religion in art at different periods in history. This borders on the banal when the art in question is, for example, medieval: most museum-goers are accustomed to seeing altarpieces, reliquaries, and liturgical implements in exhibitions of medieval art, and they know implicitly that art of that era was created mostly in the service of religion. Yet when the art belongs to more recent times — any post-Enlightenment period — the opposite tends to be true. After all, we all learned in art history class that with the advent of modernism, religion and art went their separate ways, never to meet again. To be sure, the relationship between art and religion changed dramatically at that time, and the vast majority of modern and contemporary artists use religious traditions and themes as a minor source of inspiration at best. But, can we generalize and assume that a second look is not worth it? — a second look, that is, at the way in which modernism dealt with concepts of faith, biblical traditions, and their relationship with the history of art inspired by, and put in the service of, religion. We at the Museum of Biblical Art believe that the answer to this question is "No," and that a new analysis of these issues, from the perspective of the early twenty-first century, will shed light on previously overlooked developments, and possibly invite a revision of the canon.

The art of the French painter and printmaker Georges Rouault (1871–1958), and particularly the print series *Miserere et Guerre*, which forms the object of our exhibition, offers a perfect opportunity to begin this type of conversation. Rouault was a profoundly religious artist whose subject matter is often Christian (either overtly or metaphorically), and his critical fortunes well illustrate the twentieth century's attitude toward religious subject matter in modern art. The painter himself once noted that his art "disconcerted everybody." It probably still does, and yet today it could acquire a new relevance, presenting itself as a deeply felt reaction to a world torn by war and suffering. Rouault's response to the horrors he witnessed during World War I was to retreat into metaphor and the promise of faith. His works depict Christian subjects directly (both narrative and devotional), as well as metaphorically: a lonely clown, rejected by society

and damaged by his untruthful life, becomes a present-day Man of Sorrows; a prostitute, stealing a moment of happiness with her child, stands in for the Virgin Mary. Thus, iconic images from the traditions of Christian art can gain a fresh meaning for Rouault's audience today, who can relate to, and subsequently better understand, the deep human emotions reflected in his work.

Rouault's *Miserere* prints, then, become an illustration of the ways in which religious imagery can be successfully "modernized" and made relevant for a contemporary audience. The timeless becomes actual, the literal becomes metaphoric, as the language of modern art embraces centuries-old iconic images without appearing anachronistic. Our exhibition invites you on a journey of discovery: to discover — or perhaps rediscover — the beauty, sadness, relevance, and faith of the *Miserere* prints. We believe they will resonate with an American audience at the beginning of the twenty-first century as poignantly as they did with their original viewers.

The exhibition in New York and this beautiful catalog would not have been possible without the generosity of Howard and Roberta Ahmanson; we are grateful to them for their commitment to making important works of art more widely known, and their timely interest in revising the dialogue about the place of religion in art. My deepest gratitude also goes to Sandra and Robert Bowden, whose passion for education through museums and advocacy of MOBIA's mission led to the generous offer to part with the prints on a long term basis, so this exhibition can travel nationally after its run in New York.

I am indebted to them and to all the talented and knowledgeable people who made this exhibition happen. MOBIA Curator Holly Flora organized the exhibition and edited the catalog, recognizing that the *Miserere* prints — which have not been seen together in New York City in over twenty five years — would resonate anew in this time of global turmoil. The catalog also includes the first scholarly study specifically concerning the *Miserere* series, by Professor Soo Yun Kang, and a commentary on Rouault's printmaking techniques by Dolores DeStefano, MOBIA's Curator of Education. I would also like to thank the rest of MOBIA's staff, each one of whom contributed, directly or indirectly, to the success of this exhibition, and our talented photographer, designers, and art handlers, who took the abstract concept and made it into a beautiful visual experience.

We hope that you will enjoy the (re)discovery of one of the most unique artists of the twentieth century, and that our exhibition will elicit a new look at modernism's relationship with religion, fostering the discourse on art, faith, suffering, war, and the creative imagination.

ENA G. HELLER
Executive Director, Museum of Biblical Art

GEORGES ROUAULT: ARBITER OF SHADOWS

A dying, shipwrecked man utters his last sentence, declaring that tomorrow will be beautiful. A poor woman struggles down the road carrying a heavy load on her back. A barren suburban street is outlined in shadows. These are among the haunting impressions in Georges Rouault's *Miserere* print series, originally titled *Miserere et Guerre* ("have mercy," a quotation from Psalm 51, and "war").[1] Rouault began working on this album of prints in 1912, but it remained unpublished until 1948, by which time the artist had witnessed the immense destruction of World Wars I and II, and with them, the complete transformation of the European landscape. In *This Anguished World of Shadows: Georges Rouault's Miserere et Guerre*, MOBIA presents all fifty-eight prints from the series, offering a close look at this artist's poignant commentary on the hardships of war and the promise of redemption.

The title of the exhibition comes from a poem Rouault wrote to accompany the prints:

Form, color, harmony
Oasis or mirage
For the eyes, the heart, and the spirit
Toward the moving ocean of pictorial appeal

"Tomorrow will be beautiful," said the shipwrecked man
Before he disappeared beneath the sullen horizon

Peace never seems to reign
Over this anguished world
Of shams and shadows

Jesus on the cross will tell you better than I,
Jeanne in her brief and sublime replies at her trial[2]
As well as other saints and martyrs
Obscure or consecrated.[3]

Here, Rouault laments the "anguished world / Of shams and shadows," declaring that the cry of this tortured world is best heard through humanity, whether via images of "Jesus on the cross" or "other saints and martyrs / Obscure or consecrated." For Rouault, "obscure" saints were the everyday people who experienced the sufferings of war personally, from prostitutes to soldiers to mothers. The *Miserere* is therefore a patchwork of diverse figural representations; images of a clown (plate 8) and members of the bourgeoisie (plate 52) alternate with traditional Christian themes such as the Crucifixion (plate 20) and Veronica's veil (plate 58). He thus treats overt Christian subjects and renderings of contemporary individuals as interchangeable, identifying the misery of war with the torments experienced by Christ.

Rouault's tragic vision resonated with wartime and postwar audiences in Europe and the United States. In the final months of World War II, the Museum of Modern Art in New York mounted a major exhibition of the art of Rouault, who was then seventy-four years old. The exhibition opened in February of 1945, and included many of Rouault's best-known paintings and several prints from the as yet unpublished *Miserere* series. In his catalog essay, James Thrall Soby acknowledged that Rouault's art accorded with general postwar sentiments, but also declared its timelessness:

Rouault's fame rests on surer ground than non-conformity and sudden psychological accord with the times. Viewed less emotionally, in relation to other living artists, he emerges as one of the few major figures in twentieth-century painting.[4]

Sixty-one years after that MoMA show and the end of World War II, however, it seems that Rouault is no longer seen as one of the "major figures" in twentieth-century painting. Only a handful of art historians have written on Rouault in the last ten years, and the most recent monograph on Rouault, published in 2000, was the first in almost thirty years.[5] While almost every major collection of modern art holds works by him, they are often not exhibited.[6] Rouault seems to have had a more lasting impact in Europe; a major exhibition on his early works was held in Paris and London in 1992–93, while the last significant exhibition in the United States was in 1953.[7] Likewise, although the *Miserere* print series has been exhibited more recently in smaller museums and galleries in both America and abroad, it has not been featured in a New York museum since MoMA's last presentation of it in 1979.[8] *This Anguished World of Shadows* at MOBIA is thus the first major exhibition of the series in New York in more than twenty-five years.

Why have scholars and museum audiences seemingly lost interest in Rouault? One explanation is the fact that Rouault's art was born out of wartime, and thus perhaps his meditations on suffering have become irrelevant. Another possibility

is that the deep religious sentiment expressed in his art no longer resonates with the post-modern viewer. But if Rouault's open expression of his Christian faith is at the heart of this post-modern neglect, then why is his art better known today in Europe than in America, where Christianity is relatively thriving? Our exhibition cannot hope to answer these questions definitively, but it is our goal to bring Rouault back into the view of American scholars and museum-goers. In this era of terrorism and war, when religion is much discussed in terms of American as well as global politics and events, a fresh look at Rouault, and especially at his *Miserere* series, could not be more timely.

Part of the reason that Rouault's art has fallen out of critical and popular favor may be that his eclectic style defies categorization. A brief survey of his early career leading up to the print series will therefore be useful, as we attempt to achieve a new understanding of his art and specifically of the *Miserere*. Georges Rouault was born in 1871 in Belleville, a working-class neighborhood of Paris. His grandfather encouraged him to be an artist, imparting to his grandson his admiration of such artists as Rembrandt, Courbet, Manet, and Daumier. When he was fourteen, Rouault began working as an apprentice to stained-glass makers, helping to repair such historic glass as the famous medieval windows at Chartres. During this apprenticeship, he began taking classes at the École Nationale des Arts Décoratifs, and in 1890 he enrolled in the École des Beaux-Arts, where Matisse was one of his fellow students. There, in 1891, he became the pupil and prodigy of Gustave Moreau, a key figure in the Symbolist movement, who would have an immense influence on the young Rouault. Moreau's artistic philosophy was a reaction against that of Courbet and the Impressionists, who saw art simply as a reflection of nature and/or science. Instead, Moreau encouraged Rouault to look inward, and to religion and philosophy to create art inspired by a spirituality beyond that of the tangible world. Accordingly, Rouault drew upon Christian subjects for many of his early works.

The introspective approach to art that Moreau imparted to his pupil became the foundation for the rest of Rouault's career. In the early years of the twentieth century, Rouault came to rely more and more on his faith as a source of inspiration, influenced as he was by such contemporary Catholic writers as J.-K. Huysmans, Léon Bloy, and Jacques Maritain.[9] At the same time that he renewed his commitment to Catholicism, Rouault became a keen observer of everyday life in the streets of Paris. Prostitutes and performers, which had captured the attention of avant-garde artists of his generation and the one preceding it, including such seminal figures as Matisse, Picasso, and Toulouse-Lautrec, emerged as main subjects in his art as well. Rouault's approach to these themes, however, was quite different from that of his contemporaries. Deeply affected by Léon Bloy's sympathetic commentaries on a poor woman and her family in *La femme pauvre* (1897; The Poor Woman) and other contemporary writings on Christianity and social justice, Rouault painted prostitutes and other downtrodden

figures as types of the suffering Christ. He did not abandon Christian subject matter entirely, but rather focused his Christian-themed work on portrayals of suffering, with an emphasis on the Passion of Christ in particular.

By 1905, the style of Rouault's art had changed along with its new focus. Though schooled in a more traditional, academic style, he began to paint in a fully modern idiom, using loose, expressive brushstrokes and distorted contours, as can be seen in his *Head of Christ* from 1905 (Add. 1), on loan to the exhibition from the Chrysler Museum of Art in Norfolk, Virginia. In that same year, he exhibited at the Salon d'Automne, the exhibition that was the first to cause confusion among critics of his art. There, Rouault's works were shown alongside those of the so-called "Fauves," a term meaning "wild beasts," referring to a new avant-garde group that included Matisse and André Derain. The Fauves used violently clashing colors applied with spontaneous brushwork to create a decorative, expressively non-naturalistic interpretation of figures and landscapes.[10] Rouault shared their rejection of naturalism and their use of bright colors, but his vision went beyond decoration to content— Rouault's art was also a commentary on society. Though for a time Rouault was mistakenly associated with the Fauves, then, his art in fact had more in common with that of the German Expressionists, who used a non-naturalistic representational style as a means of focusing on the spiritual as opposed to the natural world. Rouault later commented on this phase of his life, distinguishing himself from the artistic world that surrounded him:

And I began to paint with an outrageous lyricism which disconcerted everybody. . . . It was not the influence of Lautrec, Degas, or the moderns which inspired me, but an inner necessity.[11]

As implied in this quotation, Rouault did not consider himself a member of any particular movement, and despite echoes of the "moderns" that can be seen in his art, he deliberately followed a path of individualism. By World War I, Rouault's painting style had evolved yet again, from the frenetic, sinuous mode of his earliest work to the thickly outlined geometric forms that evoke the medieval stained glass Rouault worked with as a teenager. He continued to paint in this distinctive manner throughout the remainder of his life, and the *Miserere* prints are a reflection of this artistic maturity.

Soo Yun Kang's essay in this volume aptly demonstrates how the theme of earthly anguish so pointedly portrayed in the *Miserere* series was one Rouault returned to again and again, and that it had its origins in his works from the first decade of the twentieth century. She further notes that around 1905, he began to add satirical, unsympathetic depictions of the bourgeoisie to his repertoire, representing those who

inflict suffering on the poor. In particular, corrupt judges begin to appear around 1907. The array of everyday figures that later formed the basis for his *Miserere* series was thus established in his oeuvre early on. Ironically, it was at about this time that he met the art dealer Ambroise Vollard, with whom he would later become entangled in litigation over the commission of the *Miserere* print series.[12] Initially a sympathetic promoter of Rouault, Vollard commissioned the impressions in 1912. They were originally conceived of as a two-volume set totaling one hundred prints under the title *Miserere et Guerre*, and were to be accompanied with poems by the poet André Suarès. Much of the series was designed and executed between 1912–18 and 1922–27, and was finally limited to fifty-eight impressions under the title *Miserere*. Rouault disagreed repeatedly with Vollard over various details concerning production, and the dealer eventually had the first set of plates canceled. In his struggles with Vollard, Rouault perhaps felt a kinship with the oppressed souls he depicted in the *Miserere*, remarking that "it would have taken three centuries to bring to perfection the various works and paintings with which, in utter disregard of earthly limitations, [Vollard] wished to burden the pilgrim."[13] After Vollard's death in 1939, Rouault fought for the legal rights to the work, which he won. The *Miserere* was thus at last officially published, with a preface by Rouault, in Paris by the publisher L'Étoile filante in 1948.

As Dolores DeStefano explains in her essay on Rouault's printmaking techniques, Rouault executed several sets of prints over the course of his career, in both color and black-and-white. He spent countless hours perfecting his impressions. After making drawings and then paintings as studies for the prints, he had plates made after the paintings using a photoengraving technique. Then, when he had made prints from this initial plate, he would alter the plate directly using physical techniques, with printmaking tools like the burin and the roulette, and then layer impression over impression. The resulting prints replicate the forceful tonalities of his paintings, but in the case of the *Miserere* and his other black-and-white series, these have a subtle, diffused *sfumato* that is intensified by their limited palette of grays and blacks.

Rouault executed studies before and after the *Miserere* prints, including *Head of a Clown* (Add. 4), on loan from the Indianapolis Museum of Art, likely made after plate 8. The juxtaposition of this painting with its related *Miserere* image will allow viewers to appreciate the relationship between Rouault's painting and printmaking techniques. A comparison of *Head of a Clown* with plate 8 illustrates how Rouault's subtle use of painted tonalities in the preliminary studies was designed to translate well into the black, white, and grays of his prints. Because this painting may be a study made specifically after the prints, it also reveals how Rouault's printmaking process influenced his painting, and how he viewed such

media interchangeably. As material for better understanding Rouault's printmaking processes, our exhibition also includes a color print, *The Crucifixion* of 1936 (Add. 5), related to plate 31 of the *Miserere* series, and an early-stage impression, *Resurrection* (Add. 3), an image originally intended to be included in the *Miserere* and which was among those that Vollard had canceled.

From the start, Rouault envisioned the *Miserere* in the tradition of devotional art. Inspired both by medieval imagery and by medieval philosophy as re-interpreted by Jacques Maritain, Rouault created a series of images that, like icons, invite quiet contemplation.[14] Rouault's unique contribution both to the history of art and to the history of religious art with the *Miserere* is his blending of overtly religious iconography with modern, subtle, and introspective portrayals of human misery. The *Miserere* therefore is at once true to the traditions of Catholic spirituality and, in its capacity to capture the emotions of contemporary life, accessible to a modern sensibility. In plate 18, for example, a "condemned man," a prisoner, is shown stripped to the waist with his head bent in sorrow in the same pose as seen in plate 3, which is an image of Christ titled "toujours flagellé" ("eternally flagellated"). In both images, the nakedness (as opposed to nudity) of the figures implies vulnerability, and the treatment of the flesh tones in the printmaking process results in a mottled appearance suggestive of wounds or disease. In plate 3, the effect reads more as spots of blood or bruises on the flesh of Christ, while in plate 18, sharp, elongated hatch marks around the torso, neck, and face create a more subtle sense of wounds inside the body. The condemned man's wounds are thus perhaps more wounds of the soul than of the flesh. This subtle distinction hints that the wounds of Christ are universal wounds carried by everyone, whether inwardly or outwardly, and Rouault thereby translates a poignant biblical image into the vernacular. Such imagery encourages the viewer to envision his or her suffering in light of Christ's own painful experience of the human condition. Like medieval images designed to promote emotionally intense prayerful visions, the *Miserere* was designed to move the soul, and to prompt the viewer to see the relevance of age-old Christian themes to his or her own time.

Unlike many works of modern and contemporary religious art today, however, the *Miserere* was recognized even in Rouault's lifetime not only for its powerful religiosity but also for its artistic merit. In his introduction to the book that accompanied the 1952 exhibition of the *Miserere* prints at the Museum of Modern Art, Monroe Wheeler declared that "in the particular category of modern religious art, [the *Miserere*] is perhaps the greatest single work."[15] As a museum that serves as a bridge between scholarly and religious communities and one that recognizes the impact of faith on the history of art, MOBIA seeks to provide an up-to-date and relevant view of the *Miserere* for today's audiences, one appealing to both art historians and to those interested in these works as devotional images. Our installation of

the prints, timed to coincide with the Lenten Season of 2006, invites viewers to consider Rouault's vision of suffering anew. In addition to this catalog's scholarly essays, we have included biblical quotations alongside the reproductions of the *Miserere* prints, inviting visitors to consider these images, as Rouault did, as opportunities for meditation, whether on the Christian faith or on the universal human experience of suffering. Although rendered with thick black outlines and diffused gray tonalities that evoke the smoke and darkness of a world destroyed, the *Miserere* prints simultaneously have the luminescence of stained glass, hinting of light breaking through the darkness. While somber, they nonetheless allude to the promise of redemption, for as Rouault knew well, behind every shadow is a source of light.

HOLLY FLORA
Curator of Exhibitions, Museum of Biblical Art

Endnotes

[1] "Miserere" is from the Latin version of Psalm 51. The first verse reads: "Miserere mei Deus secundum magnam misericordiam tuam et secundum multitudinem miserationum tuarum dele iniquitatem meam"; in English (King James Version): "Have mercy upon me, O God, according to thy loving-kindness: according unto the multitude of thy tender mercies blot out my transgressions." This psalm is one of the seven Penitential Psalms to be prayed on the days of Lent according to the Catholic tradition established by Pope Innocent III (r. 1198–1216).

[2] By "Jeanne," Rouault here refers to the medieval martyr Joan of Arc (1412–1431), famous for her participation in the Hundred Years' War (1337–1453) and her defiance at her trial after she was captured by the English. She has long been invoked by French writers as a personification both of France and of the Catholic faith.

[3] Translated from the French by Monroe Wheeler and reprinted in Museum of Modern Art, New York, *Miserere*, with a preface by the artist and an introduction by Monroe Wheeler (New York: The Museum, 1952), preface.

[4] Museum of Modern Art, New York, *Georges Rouault: Paintings and Prints*, with contributions by James Thrall Soby, et al. (New York: The Museum, 1945), 5. Exhibition catalog.

[5] The latest monograph on Rouault is Soo Yun Kang, *Rouault in Perspective: Contextual and Theoretical Study of His Art* (Lanham, Md.: International Scholars Publications, 2000). The previous two monographs before Kang's study were both published decades earlier; these are Lionello Venturi, *Georges Rouault* (New York: E. Weyhe, 1940; 2nd edition, Paris: A. Skira, 1948), and Pierre Courthion, *Georges Rouault. Including a Catalogue of Works Prepared with the Collaboration of Isabelle Rouault* (New York: H.N. Abrams, 1962).

[6] At the November 20, 2004 re-opening of the Museum of Modern Art, for example, none of the works by Rouault held by MoMA were on view.

[7] The most recent exhibition mounted by a major European institution was on view at the Centre Georges Pompidou in Paris in 1992, continuing on to the Royal Academy of Arts in London in 1993. A short (80 page) catalog was produced for this exhibition: Royal Academy of Arts, London, catalog by Fabrice Hergott and Sarah Whitfield *Georges Rouault: The Early Years, 1903–1920* (London: The Academy, 1993). Although a number of smaller museums and galleries in the United States have featured Rouault's prints, MoMA's *Rouault Retrospective Exhibition, 1953,* was the last major American exhibition devoted to Rouault.

[8] The 1979 circulating exhibition *Rouault, Miserere* was organized by the Museum of Modern Art and directed by Riva Castleman. Many of the more recent presentations of *Miserere* in the United States have been in smaller museums, and accompanying publications have not been produced. For example, the *Miserere* series was exhibited at the Haggerty Museum of Art, Milwaukee, Wisconsin, March 16–April 30, 2000, and at the Flora Lamson Hewlett Library at the Graduate Theological Union, Berkeley, California, October 5, 2005–January 13, 2006.

[9] For a treatment of Rouault's art in the context of such writers, see Soo Yun Kang, "A Spiritual Interpretation of the Vernacular: The Literary Sources of Georges Rouault," *Logos* 6:2 (Spring 2003): 108–24.

[10] For Rouault's relationship with the Fauves, see Museum of Modern Art (1945), 14, and Ellen C. Oppler, *Fauvism Reexamined* (New York: Garland Pub., 1976), 43.

[11] Georges Charensol, *Georges Rouault, l'homme et l'oeuvre* (Paris: Éditions des quatre chemins, 1926), 23, quoted in Museum of Modern Art (1952), 12.

[12] For Rouault's relationship with Vollard, see Maurice Coutot, "Rouault et son acheteur," *Arts de France* Nos. 15–16 (1947): 35–38.

[13] Museum of Modern Art (1952), introduction.

[14] See Kang, "A Spiritual Interpretation of the Vernacular," 120-21, as well as William A. Dyrness, *Rouault: A Vision of Suffering and Salvation* (Grand Rapids, Mich: Eerdmans, 1971), 42.

[15] Museum of Modern Art (1952), introduction.

NEVER SATISFIED: THE MAKING OF MISERERE ET GUERRE

IN a monograph on Georges Rouault, Lionello Venturi reported that the artist rarely painted during the decade following World War I, instead concentrating almost entirely on printed works.[1] Rouault later corrected this statement, saying he often took time out from printmaking to paint.[2] However, from the labor that he clearly put into just the *Miserere et Guerre* series, one might be inclined to take Venturi's word for it.

A notable feature of this series is the extensive work Rouault put into the preparation of the printing plate. Most scholars agree that it is impossible to determine the exact technique he used on any one plate just from looking at the series of finished prints. Even those art historians who were able to question Rouault about his printmaking techniques were often stymied since the artist never fully explained his working process, other than to say that he used a combination of methods.[3] What we can determine is that he pursued certain techniques painstakingly and with a complex understanding of the possibilities and limitations of printmaking.

Although Rouault's methods are obviously complicated, the general idea behind the printing process is relatively simple. A base, usually made of metal, wood, or stone, is prepared so that certain parts of it will hold ink and others will not. Paper (or another material that is able to be printed) is then pressed against the base and an image is transferred to the paper. Printing allows for the multiplication of the same image, so its invention enabled artists to disseminate their work to much larger audiences.[4]

Since the invention of the printed image, artists and printers have developed various techniques to transfer their designs to paper with ever-increasing fidelity. In general, the most popular methods, and those that Rouault used, fall under the category of intaglio. Intaglio can be defined in opposition to relief: in relief, you cut away the parts that you don't want to print, and the highest parts are left to be inked (like a rubber stamp). Woodblocks are a common type of relief printing. Intaglio works the opposite way: the design is cut into the base, the lowest parts are inked and printed, and the highest parts maintain the color of the paper. Instead of creating a negative of your image (coloring in the parts you don't want colored, if you will), you are creating a positive, sometimes literally drawing on the base itself. Intaglio allows artists to include

a greater wealth of detail in their prints, as well as more convincing shading and shadows.

While we know that Rouault pursued intaglio printing of some kind, there are so many different intaglio processes, and some of them look quite similar, that it becomes difficult to define his work further. Possibly the most well-known forms of intaglio printing are engraving and etching. Both are usually done on metal bases, called plates, which are frequently made of copper. Copper is both easy to incise and sturdy enough to withstand pressure from a printing press. Engraving involves the use of tools to cut an image into the plate. Many different tools can be used to make an engraving, each creating its own characteristic look: burins (also known as gravers), drypoint needles, mezzotint rockers, and roulettes are just a few examples (figure 1).

Once the cutting of the image is complete, the incised lines are inked. The inked plate is placed in a printing press along with wet paper, and then a great amount of pressure is used to force the ink from the plate onto the paper. The resulting print can often be recognized as an engraving by the slightly raised quality of its lines, which is caused by the force of the press. These ridges are not visible in the *Miserere et Guerre* series, but the character of some of Rouault's line work indicates that he did use such engraving tools as the drypoint needle and the roulette (a tool with a small wheel that creates a perforated line). Examples of these methods can be found in the clear, sharp lines in the arch surrounding Christ's head in plate 1, *Have mercy upon me, O God, according to thy loving-kindness*, and in the shadows on the clown's cheek in plate 8, *Who does not put on make-up?* (figure 2).

Despite his use of engraving tools, Rouault seemed to favor etching processes. Etching follows the same principles as engraving, but with a very different method of cutting into the plate. Usually made of metal, the plate is first coated with an acid-resistant ground. With the help of a tool, the design is executed through this ground, but not into the plate.[5] The plate is then soaked in an acid bath. The areas covered by

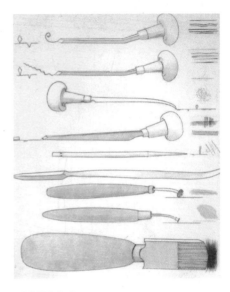

FIGURE 1

Engraving (1994) of engraving tools and the effects they produce by Amy Worthen. From top to bottom, square burin or graver; lozenge burin or graver; stipple graver; multiple line graver; drypoint needle; scraper and burnisher; two sizes of roulette; mezzotint rocker.

FIGURE 2

Plate 8, *Who does not put on make-up?* (detail)

Plate 56, *In these dark times of vainglory and unbelief, vigilant is Our Lady of the End of the Earth.* (detail)

the acid-resistant ground are not affected by the acid bath, but the lines that were incised in the ground are bare, and thus are bitten into the plate by the acid. These bitten lines therefore comprise the eventual design. After the acid-resistant ground is removed from the entire plate, it is inked and then passed through the press just as in the engraving process. Because of the action of the acid, etched lines have a rougher and coarser quality compared to the sharp, clear lines characteristic of an engraving. Rouault may have used an etching process to create the mottled quality of the woman's chin and neck in plate 56, *In these dark times of vainglory and unbelief, vigilant is Our Lady of the End of the Earth* (figure 3).

Although it is often difficult to tell if Rouault's simple black lines were etched or engraved, there are areas of his prints that could probably only have been accomplished through a complicated etching process. In these areas, the marks of an ink-dipped brush are evident, an effect impossible to accomplish using only a tool. In a process called lift-ground etching, the artist paints his design directly onto the plate with a water-soluble solution that usually contains sugar. The plate is then coated with a water-permeable yet acid-resistant ground. When soaked in water, the areas painted by the artist will be lifted off of the plate along with the ground. The areas that were brushed with the sugar solution will thus be laid bare. When the plate is then placed in an acid bath, the acid will bite the bare areas, and the marks of the artist's paintbrush will be faithfully replicated in the full plate.[6] Obvious signs of brushwork are found around the sun in plate 29, *Sing Matins, a new day is born* (figure 4), and in the cross around the general's neck in plate 51, *Far from the smile of Reims.*

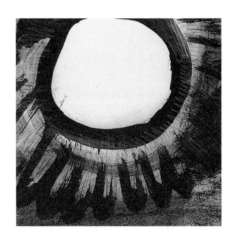

Plate 29, *Sing Matins, a new day is born.* (detail)

Some of these same "brushstroked" areas in Rouault's prints display tonal effects that are characteristic of yet another type of etching, the aquatint. In aquatint, areas that are to remain white are stopped out (that is, blocked out) with varnish, and then a resin, either in powder or solution form, is applied to the remaining areas of the plate. As before, the plate is next immersed in an acid bath, the acid biting into the small areas between the bits of the powder or in the cracks of the

dried solution, creating a network of very fine lines that gives the effect of overall color tonalities, rather than one of distinct lines. A very characteristic example of the aquatint technique can be found in the background of plate 2, *Jesus despised* (figure 5).

In order to create an aquatint effect in these "brushstroked" areas, Rouault may have used a technique called sugarlift, which is similar to lift-ground etching; the artist paints with an ink-sugar solution directly onto a varnished plate, and a water bath causes the ink to lift the varnish, allowing the artist to aquatint only the bare areas. Sugarlift aquatint thus translates effects from the artist's brush into a print, creating washes of color in the process. Many of Rouault's strong contour lines, especially the ones that delineate bodies, display the characteristics of this technique. Since these contours, which resemble the lead cames[7] of stained glass windows, were so integral to Rouault's paintings, he must have been particularly interested in finding the right technique to translate them more or less intact to his prints.

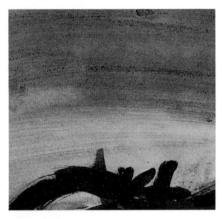

FIGURE 5
Plate 2, *Jesus despised*. (detail)

All of these processes—engraving, etching, aquatint, etc.—can be combined. Etching processes can also be accomplished in a successive fashion, meaning that the acid is allowed to bite into the plate for a short time, more lines are incised in the ground, and then the plate is placed in the acid again, creating lines and tones of lighter and darker shades. This is yet another reason why it is difficult to determine the exact type and order of the techniques used by Rouault in specific plates. In addition, some of the more painterly techniques, such as lift-ground etching and aquatint, can be easily mistaken for or confused with photogravure (also known as heliogravure), the photomechanical process that was used to make the original plates.

Probably in the interest of speed and fidelity, Ambroise Vollard, Rouault's dealer, insisted that his original paintings for the *Miserere et Guerre* series be first transferred to plates by photogravure. Photographs were taken of the original paintings (which would have been gouache or oil), and each negative was then developed onto the printing plate and etched into it through a successive process, producing a near-perfect reproduction of the original photograph. Thus, it is difficult to tell whether the brushstrokes in Rouault's prints come from the initial photogravure, or from an additive aquatint (possibly sugarlift) that he applied to the plate later. For example, the background of plate 2, used above as an example of the aquatint technique, could just as well be a reflection of Rouault's application of paint on the original canvas.

FIGURES 6A & 6B

A *Tenderness*, n.d.
 Heliogravure
 22 ½ x 16 ⅛ inches
 Impression from plate created
 through photomechanical process.

B *Tenderness*, n.d.
 Aquatint, roulette, and drypoint
 over heliogravure
 22 ½ x 16 ⅛ inches
 Impression from plate after
 Rouault altered it by hand.

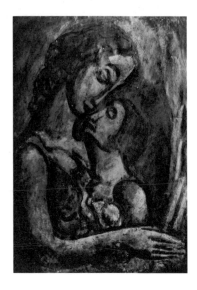
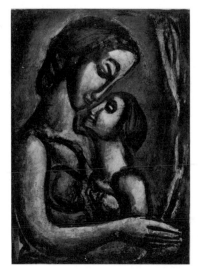

What we can determine from looking at the completed prints and the proofs that are available to us today is that Rouault was not satisfied with the initial mechanical process. To the dismay of Vollard, who had perhaps hoped that photogravure would decrease the need for (and expense of) manual labor, Rouault spent the greater part of the years 1914–18 and 1920–27 personally altering each plate until it had achieved perfection in his mind. He wrote, "Never satisfied, I resumed each subject endlessly, sometimes in as many as twelve or fifteen successive states; I should have liked them all to be of equal quality."[8]

Rouault's method of working is easily demonstrated by the differences between the proof and the finished print of plate 13, *it would be so sweet to love* (figures 6A & B). He has burnished (polishing until the ink will no longer adhere to the plate) out sections, added drypoint lines, scratched the plate with a roulette, and possibly applied aquatint. We probably will never know the order in which he undertook these methods, but we can assume that this was a process of trial and error: burnishing one section, etching another, and always making test prints to see how the work was progressing. The picture that eventually emerges is one of an artist obsessed with extracting the most expressive qualities of his work as fully as his medium would allow.

DOLORES DESTEFANO
Curator of Education, Museum of Biblical Art

Endnotes

[1] Quoted in: Museum of Modern Art, New York, *Georges Rouault: Paintings and Prints,* with contributions by James Thrall Soby, et al. (New York: The Museum, 1945), 21. Exhibition catalog.

[2] Ibid., 36.

[3] Ibid., 29.

[4] Printing on textiles was invented as early as the 6th century AD, but it was not until paper (a cheaper substrate than textiles) came into use in Europe during the 14th century that printing technologies really began to flourish.

[5] There are also other more complicated methods that allow an initial design on paper to be wholly transferred to the ground.

[6] It is also possible that Rouault brushed acid directly onto the plate to transfer the effect of his brush, but this technique can be unpredictable.

[7] A came is a lead strip that is used to fasten together panes of glass, most familiarly in stained-glass windows.

[8] Museum of Modern Art, New York, *Miserere,* with a preface by the artist and an introduction by Monroe Wheeler (New York: The Museum, 1952), preface.

Suggestions for Further Reading

Gascoigne, Bamber. *How to Identify Prints: A Complete Guide to Manual and Mechanical Processes from Woodcut to Inkjet.* Second edition. New York: Thames & Hudson, 2004.

Griffiths, Antony. *Prints and Printmaking: An Introduction to the History and Techniques.* Second edition. Berkeley; Los Angeles: University of California Press, 1996.

Hults, Linda C. *The Print in the Western World: An Introductory History.* Madison: University of Wisconsin Press, 1996.

Ross, John, Clare Romano, and Tim Ross. Revised and expanded edition. *The Complete Printmaker: Techniques, Traditions, Innovations.* New York: The Free Press; London: Collier Macmillan Publishers, 1990.

"IN THE DEEP FURROW":
ROUAULT'S VIEWS ON LIFE AND SUFFERING

DURING his lifetime, the eminent French painter and graphic artist Georges Rouault (1871–1958) was frequently referred to as the artist of "darkness and death."[1] His colorful late work, notable for its blissful content, is a departure from the dour subjects of tragic import that otherwise dominate his oeuvre. Rouault's subjects are not numerous: the sad clown, the lost prostitute, the poor and dispirited man or woman, the pompous bourgeois, the self-righteous judge, and Christ in the Passion appear repeatedly in his art. Whether these figures are the inflictors or the recipients, they are all related to the central theme of Rouault's entire body of work: suffering.

This persistent focus on suffering arose out of his own life of suffering, particularly in his early years. Of humble background, Rouault proudly professed, "I am born a worker, in a working quarter" (specifically, Belleville, a poor district of Paris).[2] He claimed that he had been born in "the cave," as his mother gave birth to him in the basement, where she had sought shelter from heavy bombardment during the civil war that was sparked by the German invasion of France during the Franco-Prussian War.[3] For Rouault, this traumatic birth during wartime was a sign, marking out a life of misery from the onset. He indeed experienced a childhood of hardship and poverty (Rouault referred to his own body as a carcass[4]), followed by an arduous apprenticeship under a stained-glass master. His years at the École des Beaux-Arts, although very fulfilling and beneficial to his artistic development, especially working under the tutelage of Gustave Moreau, were also filled with financial strains and mental depression. Moreover, Rouault was constantly surrounded by people with physical and emotional needs. As a child in Belleville, he witnessed all kinds of misery, affecting all ages, and then later in Montmartre, he encountered itinerant clowns and prostitutes seeking refuge and food. Many of his close friends were poor, including his spiritual father Léon Bloy, who lived in utter destitution. Suffering was everywhere around him. Suffering was an integral part of his life.

Therefore, the evident theme of Rouault's *Miserere* print series hardly comes as a surprise. Profoundly affected by World War I and the death of his father in 1912, Rouault

made numerous drawings between 1912 and 1918, as starting points for a portfolio of prints about death and war.[5] At the urging of his dealer, Ambroise Vollard, he agreed to produce two volumes comprised of one hundred prints total, one titled *Miserere* (Have Mercy) and the other titled *Guerre* (War). In the end, Rouault completed only fifty-eight of the prints, working between 1922 and 1927. The final portfolio of fifty-eight plates, renamed simply *Miserere*, was published at last in 1948.[6] In the original portfolios, each plate was laid within a double leaf printed with descriptive letterpress, that is, with the plate's title. While the majority of the titles were conceived by the artist himself, some are quotations from the Bible or well-known writers, and a few are variations on common French idioms. Plate 1, depicting the bowed head of Christ with an angel above, takes its title — as does the series as a whole — from Psalm 51:1, *Miserere mei, Deus, secundum magnam misericordiam tuam* (Have mercy upon me, O God, according to thy loving-kindness). Plate 34 is another depiction of the head of Christ, who hovers between a soldier below and the word "Guerre" above. Originally, plates 1–33 were probably intended for the *Miserere* volume, while plates 34–58 were most likely meant for the *Guerre* volume. And yet, the two sections are not all that different, as both feature similar portraits of suffering, which might have been dispersed anywhere throughout the original portfolio of one hundred plates.

As previously noted (and as the many related study pieces document), forty-two additional plates were to have been included in the series, so the *Miserere* as it stands may seem to be incomplete. This might explain the apparent lack of a storyline, or any sense of logic behind the ordering of the plates. But from another perspective, the *Miserere* can be considered a complete and coherent series, in that we know that the artist had these fifty-eight plates printed between 1922 and 1927 with the intention of publishing them in their present form.[7] A two-volume work of one hundred plates would have looked much the same as the *Miserere* of 1948, for Rouault was not prone to logical narratives or sequences, as is evident in his other famous print series, *Les réincarnations du Père Ubu* (1918–19) and *Les fleurs du mal* (1926–27). Although these two series of illustrations are based on the works of famous writers (Alfred Jarry and Charles Baudelaire, respectively), Rouault was never a slavish illustrator, even including imagery not found in the original texts. Rouault's interpretations of Jarry and Baudelaire captured the essence of his sources; rather than mere illustrations, Rouault created visual parallels to the originals, in style as well as in content.

For the *Miserere*, Rouault worked meticulously on each individual plate, producing up to fifteen trials of the same scene in an effort to reach the technical result that he intended. This was typical of the artist, who sought perfection in every work he executed. Individual plates were given his full attention, resulting in starkly marked outlines that clearly define each form standing out against a backdrop of different gradations of gray. Despite the use of only neutral colors, the subtle range of values,

from highlights to dark shadows, emulates the light effects of stained-glass windows. Individual plates invite the viewer to pay full attention to their visual elements, while also meditating on the profound thoughts evoked by each image and its title, its accompanying "text," as it were. Thematically, the plates are closely related to one another, forming an integral whole. The fifty-eight plates of the *Miserere* may appear to be a collection of disparate images dealing with war and suffering, but, in fact, they represent the specific types of people and scenes that preoccupied Rouault throughout his life. The series is entirely consistent with the artist's body of work, revealing as it does the bearers of misery as well as the inflictors of pain. Although highly selective in its range of types, taken together, the protagonists of the *Miserere* represent the essential components of the artist's microscopic world of suffering, a world leading to the rejection of God and the subsequent need to return to Him. Hence, "Have mercy upon me, O God."

The *Miserere* is made more comprehensible when the plates are placed in the context of Rouault's earlier works, to which they are directly connected. Some of the figures are ambiguous, but they can be traced to earlier works that reveal their prototypes. Certain images, in fact, can be understood only in relation to their antecedents. While there are depictions directly related to war, the series is rife with Rouault's trademark images. There are new images of soldiers and general scenes of France, which can be traced back to earlier fighting scenes and landscapes, but the *Miserere* is marked predominantly by three major types that Rouault developed over the years: images of Christ, who appears in sixteen plates; various renderings of the poor, including a clown and a prostitute, appearing in seventeen plates; and variations on the bourgeoisie, counting for eleven plates. These three types dominate the *Miserere*, as they do the entire oeuvre of the artist. The portfolio displays a constantly shifting alternation among these three types.

Some of these characters, or types, appear together in the same plate, and certain themes overlap, yet there is a sense of organization of types and scenes in the *Miserere* as a whole. All of the plates can be categorized either by subject or by theme. Although not a precise system, as was never intended by the artist, who organized the plates according to the flow of the spirit, rather than by any kind of intellectual schema, the *Miserere* can be seen generally to be ordered as follows:

PLATES		20–21: Christ[8]	39–41: the bourgeoisie
		22–24 the poor	42–43: the poor
1–3:	Christ	25–29: the spiritual state	44–48: death
4–14	the poor	of France	49–52: the bourgeoisie
15–17:	bourgeois women	30–35: Christ	53–56: hope
18–20:	court scenes	36–38: war scenes	57–58: Christ

As the famous *Head of Christ* (1905; figure 7) and *Christ Mocked* (1912; figure 8) demonstrate, Rouault had produced images of Christ early in his career, but he truly began to focus on this theme in the 1920s. The *Miserere* portrayals of Christ are consistent with Rouault's painted representations of him, in that they also focus on his agony, presented close-up, in an almost iconic mode that invokes devotion. There are portraits of Christ throughout the range of fifty-eight plates, but most notably at the beginning and at the end of the work's two putative sequences, the *Miserere* and the *Guerre* "sections." Almost all depict scenes from the Passion, showing Christ on the cross, with the crown of thorns, or with his head downcast. Plate 33 portrays Christ through the imprint of his face on St. Veronica's veil.[9] The portfolio opens with three images of Christ in moments from the Passion, but increasingly, as the series progresses, his suffering is linked to that of mankind, portraying him not alone, but with other people. The *Miserere* section ends with four portrayals of Christ (plates 30–33) — three biblical (Jesus baptized by John the Baptist before witnesses; at the Crucifixion with his disciples; and after the Resurrection appearing to a follower) and one apocryphal (St. Veronica's veil). Christ is alone in the form of the printed image on the veil, but there is a specific reference to St. Veronica in the title of plate 33, *and Veronica, with her soft linen, still walks the road* . . . As noted, the *Miserere* section opens with images of Christ suffering by himself, or with an angel (or the Holy Spirit), as in plate 1 (he came from heaven, the angel seems to indicate, to touch people on earth); but it closes with Christ in close dialogue with his followers.

The *Guerre* section, however, shows or makes reference to other people in all of its depictions of Christ. Veronica's veil, carrying his pain-ridden face, appears in scenes of dying and killing (plates 46–47), signifying Christ's grief and sympathy, as well as his actual presence at those tragic moments. In this latter section, Christ is made relevant to the present, as he or his image appear in contemporary scenes in the midst of people of Rouault's own time. And his suffering is not of the past, but of the present: *"Jesus will be in agony until the end of the world* . . . *"* (plate 35). His persecutor is not the Pharisee of the past, but a modern-day leader who arrogantly dares to confront him (plate 40). The *Guerre* section also ends with Veronica's veil (plate 58), but here, there is no direct reference to Veronica or to the past in the plate's title. The permanently imprinted face of Christ stands as an eternal symbol of his suffering for humanity: *"It is through his wounds that we are healed."* The *Miserere* Christs are not a random selection of various delineations of Christ in suffering, making sporadic appearances to point to the need for his intervention in this world without hope. On the contrary, Rouault's intentions were deliberate: to show Christ's relevance to the past as well as to the events and people of the present, a theme the artist would gradually develop through the *Miserere*'s different evocations of Christ.

In the *Miserere*, the scenes of the poor are directly linked to earlier works by Rouault. Plate 4 is a characteristic scene of a family in exodus, a type of scene that

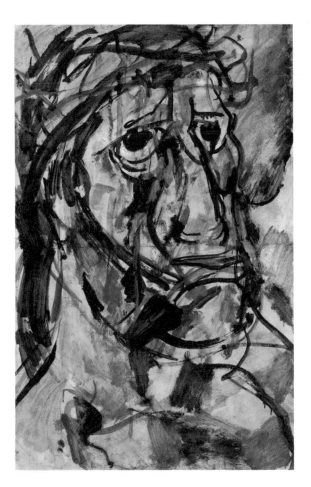

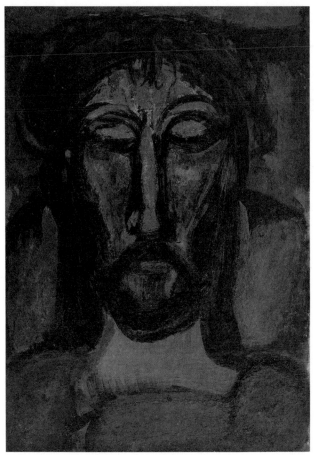

FIGURE 7
Head of Christ
Oil on paper and canvas, 1905
39 x 25 ¼ inches

FIGURE 8
Christ Mocked
Oil on canvas, 1912
17 x 12 inches

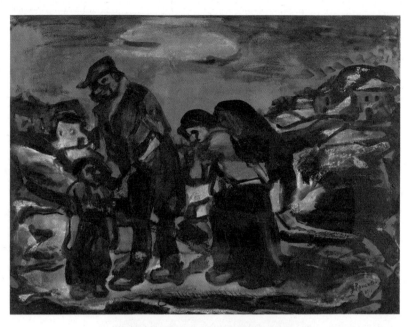

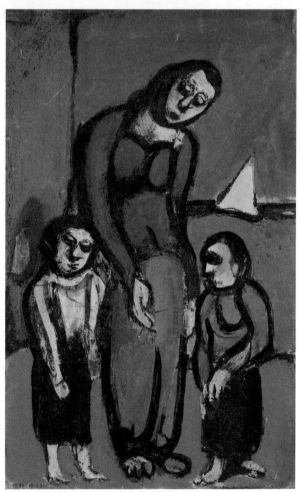

Rouault depicted most frequently during the second decade of the twentieth century.[10] As in *The Fugitives* (1911; figure 9), a parent walks with her head downcast, a heavy burden on her back, while an accompanying child walks upright and is sprightly in attitude. Plates 6 and 9 are variations on this theme of the migrant poor. And yet another migrant parent shouldering a heavy burden — a literal symbol of the daily burdens of her life — is represented in plate 24, *"Winter, leper of the earth."* This last scene recalls the many barren winter landscapes, featuring either a few lonely houses or a handful of scattered figures, which Rouault produced in that same decade. Winters are especially hard on the poor, forcing them to cope with cold weather on top of their other basic needs; as Rouault wrote in one of his poems, "harsh winter / detested by the poor people."[11] In the poem, a mother sings her child to sleep, so as to forget about the hardships of their daily life in dreams. Thematically, Rouault's poem is connected to the *District of Long Suffering* series that the artist also produced in the second decade of the twentieth century, scenes depicting the poor in their depressed residential neighborhoods of simple rectangular houses, including such powerful studies as *Mothers and Children* (1911; figure 10). These are the prototypes for plates 10, 13, 23, and 42 in the *Miserere*.

Rouault began to write poetry in the early 1900s, but as he would with the *Miserere* plates, he continued to obsessively polish most of his poems over time, finally publishing them years after they were first drafted. He composed many pieces in the 1920s, while working on the *Miserere* prints, so similar themes and motifs are to be found in both mediums. For example, Rouault wrote several poems about poor mothers. Here is a poignant one that is particularly relevant to plate 24, but also generally to all of the depictions of the poor in the *Miserere*:

Go, old mother.
Here is winter
The sky is low
The weather is dull
The soul heavy.
.
Go, old mother.
Everything is misery
To poor folks.
To those who for their possessions have
Only their two arms
Everything is misery
In times of peace
And still more during war
Everything is misery.[12]

The portrait of the clown, *Who does not put on make-up?* (plate 8), also falls under this broader theme of the poor. Rouault went to the circus when he lived in Montmartre, and over the years he encountered many itinerant clowns. He understood their lifestyle, having to hide their tragic lives of rejection and poverty as they entertained people with jokes, antics, and smiles while decked out in gaudy costumes, and all this just to make a living. Plate 5 is also based on circus characters, originating from the "Wrestler" and "Acrobat" figures of 1913, which employ the identical pose of a hand placed on a bowed head to denote sadness or oppression.[13] Many of Rouault's clowns are branded "tragic" or "gloomy," like the Zurich *Head of a Tragic Clown* (ca. 1904–05; figure 11), or they wear sad expressions, as do the figures in both *The Old Clown* (1917; figure 12) and the *Miserere* clown, whose title alludes to the dual life of the clown. This duality ties the *Miserere* clown to the plate that immediately proceeds it, the portrait of a king bearing the title *believing ourselves kings* (plate 7). These two plates point to the duality of human experience, whereby we present a rosy picture of ourselves in public, either out of necessity or because we want to create an illusion. Rouault's life-goal was to unravel that surface life, and to disclose people as they really are underneath their masks. This point is well illustrated in the much quoted letter of 1905, in which Rouault traced the development of his thought out of an encounter he once had with a poor itinerant clown:

That nomadic wagon, parked on the road, the emaciated old horse eating thin grass, the old clown seated on the side of his trailer mending his glittering and colorful costume, the contrast of brilliant, scintillating things, made to amuse us and this life of infinite sadness. . . . I clearly saw that the "Clown" was me, it was us. . . . This rich and spangled costume is given to us by life, we are all clowns more or less, we all wear a "spangled costume," but if we are caught unawares, as I surprised the old clown, oh! Then who would dare to say that he is not moved to the bottom of his being by immeasurable pity. It is my failing (a failing perhaps . . . in any case it is for me an abyss of suffering . . .) "never to allow a person his spangled costume," whether he is a king or an emperor. The man that I have before me, it is his soul that I want to see . . . and the grander and more exalted in his person, the more I fear for his soul.[14]

King and clown are two very different characters, but they both wear costumes that proclaim their roles in society. Their very natures are identified with the roles they play in real life. Rouault, however, cares less about the role and is more concerned with the person behind the role, and wants to uncover the real character and his/her naked soul. To achieve this, he has to first expose the mask behind which the real person is hiding. In Rouault's world, the poor, who are of little significance to society (they are essentially invisible to their social betters, according to Léon Bloy[15]) wear only thin masks, if any,

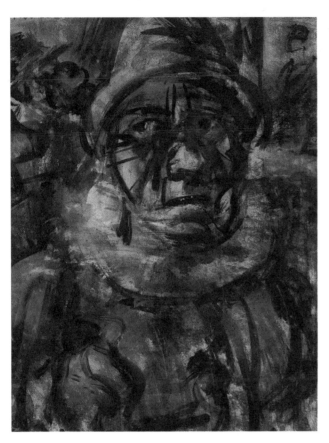

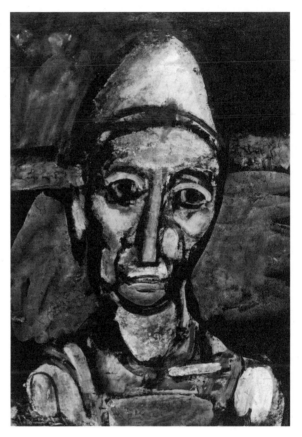

FIGURE 11
Head of a Tragic Clown
Watercolor on paper, ca. 1904–05
14 ½ x 10 ½ inches

FIGURE 12
The Old Clown
Oil on canvas, 1917
40 ⅛ x 29 inches

and are painted in all their lives of naked misery, poverty, and hardship; conversely, the bourgeoisie, having "grander" and more "exalted" positions in life, are covered with thicker masks that the artist seeks to unveil. While Rouault's depictions of the poor evoke sympathy, his studies of the bourgeoisie inspire disgust, shown as they are in all *their* lives of regalia, pomposity, and viciousness. Just as the king is rendered in a comical manner, disclosing his illusions of power, so, too, are important members of the middle class portrayed mockingly, stripping away their masks of pride and hypocrisy. These portraits also reflect Rouault's "fear" for the souls of even his grandest subjects. He wanted them to cast off their costumes and to be truthful to their inner, vulnerable selves — they, too, are poor in spirit and are in misery, and so need the Lord as much as the poor do.

It is therefore not surprising to see that, in the *Miserere*, a prostitute (plate 14) precedes the bourgeois women depicted in plates 15–17. The prostitute is indistinguishable from her bourgeois sisters in appearance, with her nicely combed hair and pearl necklace. Only the title of the plate, *A young woman called joy* (Fille dite de joie), betrays her profession, as it is a play on the French idiom "fille de joie," which means prostitute. Plate 14 is based on the many "fille de joie" images Rouault executed in the first decade of the twentieth century, but here, the *fille de joie* is rendered more closely to the types of bourgeois women that the artist depicted most frequently the following decade. The title of plate 16 is *The upper class lady believes she holds a reserved seat in Heaven.* Rouault had portrayed similarly haughty and self-righteous bourgeois women before, such as *Madame X* (1912–13; figure 13), which is accompanied by an epithet: "J'irai droit au ciel disait-elle, avec une assurance douce et ferme" (I will go straight to heaven, said she, with a sweet and firm assurance).[16] All of these women obviously have problems of their own, wearing false masks of refinement, respectability, and religiosity. Prostitute or woman of the bourgeoisie, all share the same fate of being forced to wear the specific role-playing masks that are demanded by society, masks that Rouault aimed to uncover.

Of all the masks, it is the mask of hypocrisy that Rouault despised the most and thus tackled the most fiercely. *Monsieur X* (1911; figure 14) is a counterpart to *Madame X*, an overbearing presence in respectable clothes, but whose face reveals conceit and contempt. Unlike his depictions of the poor, who are scantily clad (and therefore hardly capable of disguising themselves), and whose heads are bowed down, Rouault's bourgeoisie are presented as well dressed, bedecked with ornaments, and with their heads held high, like the people in plate 41, *Auguries.* As the plate's title explains, these three pillars of the establishment are discussing and pondering the current signs, trying to accurately predict the future.[17] While the poor work all day long to bring bread to the table (plate 22), these "spiritually" attuned members of the middle class sit idly around, speculating about events to come. Rouault especially disliked the Christian bourgeoisie, remarking that they have a "horror of all action."[18] He recalled his encounters with

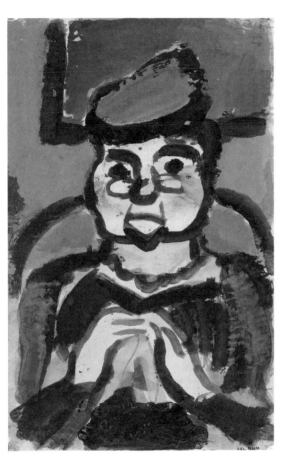

FIGURE 13
Madame X
Tempera on paper, 1912–13
12 ⅜ x 7 ⅞ inches

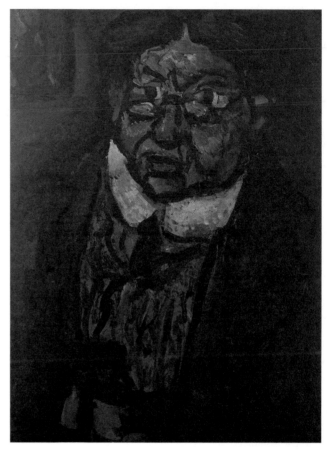

FIGURE 14
Monsieur X
Oil on paper, mounted on wood panel, 1911
31 ½ x 23 inches

hypocritical Catholics when he was young and nearly starving: "Not one of them cared about my carcass, and these good people . . . spoke only of Assurances in life while staring at me anxiously."[19] In plates 16 and 41, Rouault has exposed the outer layers of respectability and religiosity that the fine men and women of the bourgeoisie hide behind, layers that disguise a reality of hypocrisy, pride, and sloth.

Rouault's fascination with the role-playing bourgeoisie, especially those in positions of high power, grew out of his study of Alfred Jarry's 1896 play, *Ubu roi* (King Ubu). Père Ubu (Father Ubu) represents the consummate (albeit cartoonish) bourgeois: utterly stupid, hypocritical, grotesque, vulgar, and always lusting after food and power, to the point of committing crimes. Mère Ubu (Mother Ubu) is more than his equal in avariciousness; lusting after power herself, she encourages her husband to commit immoral acts to gain the crown. In 1918, Rouault produced a study image of Mère Ubu with her teeth clenched[20] (like the "emancipated" woman portrayed in plate 17 of the *Miserere*), and from that point on, he used clenched teeth to symbolize aggression. Jarry's intent behind his scatological play was similar to Rouault's artistic aims. As the playwright wrote in "Questions de théâtre," an article published in *La revue blanche* in 1897, he wanted to create an exaggerated "double ignoble" of his bourgeois audience, thereby forcing them to see their true selves.[21] Hidden beneath the polite social proprieties are all of the greed and other sins that must be exposed.

Rouault's Ubu pictures originated in a request from Ambroise Vollard to illustrate a collection of his short stories, which were based on Jarry's 1901 play *Ubu colonial* (Colonial Ubu). At Rouault's suggestion, the collection was titled *Les réincarnations du Père Ubu* (The Reincarnations of Father Ubu), for which the artist produced 22 etchings and 104 woodcuts between 1918 and 1919. Ubu is now a politician and a colonist, marching through the continent of Africa. Symbolically, Ubu can stand in for the bourgeois men of power portrayed in the *Miserere*, men whose formal attire of uniforms, hats, and medals attests to their status, as we see in plates 40, 49, 51, and 52. Plate 49 is titled, ironically, *"The nobler the heart, the less stiff the collar."* Of course, the opposite is true of these powerful men, suggesting that the more corrupt and insecure the man, the tighter and stiffer his collar. The pompous figure of plate 49 wields power by merely pointing an index finger, a gesture Rouault used to even greater effect in *The Colonial Administrator* from the Ubu series (1918–19; figure 15). Close in spirit to the Ubu prints and the portraits of the bourgeoisie dating from the second decade of the twentieth century, the *Miserere* men are stiff-necked, proud, and apathetic. Plate 51 shows how inhumane these powerful men have become, as this portrait of a cold and calculating general is contrasted with the famous sculpture of the gentle, affectionate, and smiling angel Gabriel at the entrance of Reims Cathedral, to which the plate's title, *Far from the*

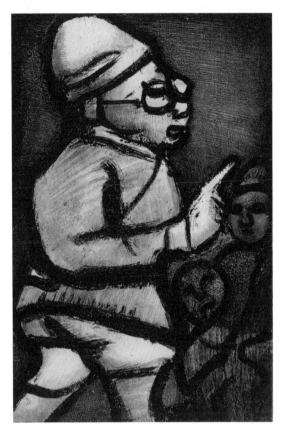

FIGURE 15
The Reincarnations of Father Ubu:
The Colonial Administrator
Etching, 1918–19 .
10 ½ x 6 ¾ inches

smile of Reims, alludes. They all hide behind the severe rules that they impose on their subjects; as the title of plate 52 states, *The law is hard, but it is the law*. Their illusions of grandeur and authority lead them to even question Christ, as the Pharisees did, which we see reenacted in plate 40, *Face to face*. Our coldly calculating rulers — civil, religious, and military — all justify war, using grandiose appeals to nationalism; but they never consider the miseries that are inflicted on the people and the land by war, the destructiveness of which Rouault so eloquently captured in plates 44, 46, 47, and 48 of the *Miserere*. How truly rational are these people, behind their masks of power and authority? Plate 39 is the picture of respectable politicians gone mad; two men are dressed in proper attire, but their expressions are comical and their eyes bewildered. The title of the plate: *We are insane*.

In the *Miserere*, the goddess of war reigns, sturdy and controlled, in plate 50. And death reigns. Her portrait is titled "*With tooth and nail*." As noted earlier, for Rouault, clenched teeth were a sign of aggression. This motif appears frequently in the series of prints that he made after Charles Baudelaire's *Les fleurs du mal*. In these, Satan and bourgeois women display their sharp teeth, ready to bite; witness the threatening woman next to the cross in *The Mocking of Christ* from the series (1926–27; figure 16). Throughout *Les fleurs du mal*, Baudelaire delineates both teeth and nails as fierce instruments of torture. The woman in plate 50 is calm and focused. Her eyes are closed and her arms folded, but the title of her portrait conveys her inner aggression, and an anger about to burst out. The goddess is intent on fully unleashing her powers to destroy humanity.

The juxtaposition of a destitute man (plate 18) with a proud, stiff-necked person (plate 19) appears to demonstrate yet another contrast in the fates of the poor and the bourgeoisie in the *Miserere*. Both plates derive from Rouault's courtroom scenes dating from the first decade of the twentieth century. Around 1907, a friend who was a deputy prosecutor allowed Rouault to observe some criminal trials at the Seine court. According to his daughter Isabelle, Rouault fully grasped the destructive force of crime, but evidently he was even more shocked by certain of the verdicts he witnessed.[22] In *The Accused* (1907; figure 17), everyone is corrupt: judge, lawyers, guards, and criminal. Rouault makes his point through the disfigurement of the bodies, and particularly the

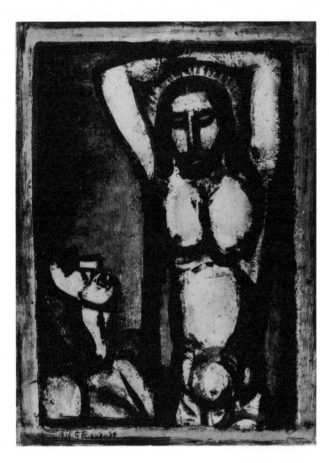

FIGURE 16
Les fleurs du mal: The Mocking of Christ
Lift ground aquatint and drypoint over
photogravure, printed in black, 1926–27
13 ⅞ x 10 ¼ inches

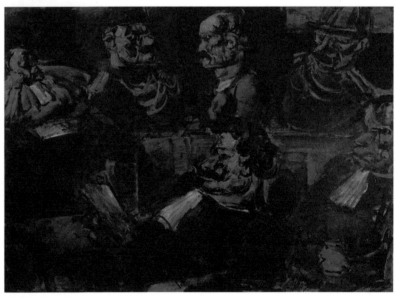

FIGURE 17
The Accused
Oil on canvas, 1907
29 x 41 inches

faces. The figures in the scene may wear fancy robes that designate their proper roles, but their faces are monstrous. Rouault is faulting an institution (the law) that is governed by imperfect individuals who impose imperfect rules on the imperfect masses. The remorseful criminal of plate 18 and the callous lawyer of plate 19 actually form a sort of triptych with the plate that follows them, an image of Christ bearing the title *under a Jesus on the cross forgotten there*. The titles of plates 18–20 are each taken from a poem by Rouault (that of plate 19 with a slight variation):

The condemned man has gone away
indifferent and fatigued
his lawyer in phrases hollow
and imposing
has proclaimed his innocence
a man in red thundering
and rising up
exonerated Society
and charged the accused
under a Jesus on the cross
forgotten there.[23]

Rouault is speaking here beyond any specific court scene. The criminal, like Christ, serves as a scapegoat for society as a whole, condemned in place of the nation. The forgotten "Jesus on the cross" is a reference to the wall behind the judge's bench in French courtrooms, which formerly would have displayed a crucifix. Prior to the legislative separation of church and state in 1905, the cross was prominent in many public places in France, including courtrooms. For Rouault, the removal of the cross from the walls of French courtrooms signified the placing of judgment in the hands of arbitrary judges. It also symbolized the fact that an entire nation, which was once firmly grounded in Christianity, no longer submits itself to God and is now left entirely to its own devices.

So, what is the outcome of man ruling man, instead of God ruling over men? Poverty, misery, hypocrisy, and war. Thus, the scenes in the *Miserere* evoking the spiritual state of France (plates 25–29), the scenes of war (plates 36–38), and the scenes of death (plates 44–48). Rouault looked to the ancients for some of his titles, including Lucan, *"The very ruins have been destroyed"* (plate 34), and Plautus, *Man is wolf to man* (plate 37). A land without worship (plate 25) is a land of eternal thirst and fear (plate 26), a land of endless tears (plate 27). Rouault cries out, *Have mercy upon me* (plate 1), and also *"Out of the depths . . ."* (plate 47), the latter a reference to Psalm 130, which opens, "Out of the depths have I cried unto thee, O Lord." Plate 47 is a scene of murder, dying,

and death witnessed by the head of Christ on Veronica's veil. Who is responsible for such tragedies? Not just the military, or the clergy, or the bourgeoisie, accuses Rouault, but all of French society, which has collectively turned its back on Christ. Rouault always renders the poor sympathetically, but he does not exempt them from guilt: plate 6, a grouping of desperate migrants, is titled *Are we not convicts?* All are guilty.

All have sinned and are condemned to die, even the poor woman of plate 43, *"We must die, we and all that is ours."* In plates 42–48, death is conveyed through both image and word. The skeleton figure as an allegory of death does not appear in Rouault's earlier work. Its multiple appearances in the *Miserere* demonstrate how Rouault was marked by his work on the *Fleurs du mal* series.[24] Baudelaire devoted a whole section of his masterwork to the subject of death, and he frequently referred to individuals as corpses. His poems bring an awareness of death to their protagonists that makes it seem imminent and real, as it did to the poet himself. Death is indeed imminent in the *Miserere*, as a skeleton approaches two soldiers in plate 36, *This will be the last time, little father!*, and the Grim Reaper arrives in plate 45, *Death took him as he arose from his bed of nettles.* In plate 28, *"He that believeth in me, though he were dead, yet shall he live,"* skulls fill the choir of a church, while a single skull has been placed beneath the cross, evoking the cross at Golgotha.

However, according to Christian thought, death is not the end. Within the scenes of death are glimpses of hope, as in the last mentioned plate, whose title is a message of life. The following plate, plate 29, shows a lifeless land, but one on which the sun rises — its title is *Sing Matins, a new day is born*. So, Rouault suggests, there is an end to this tunnel of darkness and death. The poor persevere through a life of hardship because of their hope of heaven and the dream of a better world. Even in the midst of their hard vagabond life, the refugee family learns to appreciate the beauty around them in plate 9, *At times the road is beautiful . . .*; and in plate 13, *it would be so sweet to love*, a mother and child focus on their love for each other. In plate 11, the shipwrecked man dreams that "Tomorrow will be beautiful." In plates 53–56, the Virgin keeps her vigilant watch over mankind, bodies are resurrected to face a new day, and the poor help each other. This is an alternative land of hope guarded by the compassionate Mary, where the weak help the strong, as in plate 55, *Sometimes, the blind man consoles the seeing*. The answer, then, to the sins and crimes of men is that ultimate weak being, Christ, who appears throughout the *Miserere* portfolio, commiserating with those who are poor and those who suffer, and bearing the sins of all humanity on himself.

There is hope for the artist as well. The title of plate 45, *Death took him as he arose from his bed of nettles*, comes, with one variant, from Rouault's poem "The Artist."

Death took him
when he arose
from his bed of nettles
where he slept
all of his life.

Tomorrow will be beautiful
he sang tearfully
keeping his heart
with fervor
like a divine host

Before him
the blessed road
where the Elect of the Spirit
have passed
all wounded and dazzled

He arrived at last!
the door of the house is opened
without squeaking on its hinges
it was there, the haven of grace

No one asked him
about his last residence,
his birth certificate,
nor where he ought to go
at sunrise.[25]

Looking at plate 45 with this poem in mind, the skeleton no longer seems like a negative image, but, rather, it becomes a figure of hope, rising after death and walking along the blessed road toward heaven. "The Artist" also suggests that throughout his own life of suffering, Rouault held on to his hopes of future rest and heaven.

Despite this emphasis on suffering and death, the *Miserere* is ultimately a work of hope and salvation. Rouault, in fact, felt that most people focused too much on the distortions and exaggerations of his images, assuming that his message was primarily negative and pessimistic. He wrote, "They never understood the depth of my thought toward this humanity that I seem to mock."[26] Rouault wanted to expose the real people behind their masks, so that, coming face to face with their own naked souls, they

would realize their need for redemption. His art derived from an earnest and profound compassion for all of humanity. He especially commiserated with those who suffered. "I am," he said, "a silent friend of those who struggle in the deep furrow, I am the ivy of eternal misery that attaches itself on the leprous wall behind which rebellious humanity hides its vices and its virtues."[27]

As his entire oeuvre testifies, Rouault focused on suffering. Based on his own experiences and those of others, he came to believe that suffering was an integral part of life. Theologically, he seems to have believed suffering to be an inevitable fact of life, the result of the fall of man and his being born to this cursed world of troubles. War only exacerbates the misery, confirming man's fallen state. Rouault's resigned acceptance of suffering was also encouraged by Léon Bloy, the artist's spiritual mentor. Although this writer often spoke in hyperbole, expressing himself in the flamboyant style of a pamphleteer, his message was clear. Bloy reasoned that Christ was the incarnate God who came to suffer, and since humans are made after the image of God, they also must suffer, since they, too, are made of flesh. To avoid suffering would mean the denial of one's true existence and identity, as well as the rejection of one's participation in the body of Christ. In fact, Bloy claimed that suffering is a divine privilege, since it connects one to the body of Christ, allowing us to thus attain a supernatural state here on earth.[28] Rouault's depictions of the poor and suffering in the *Miserere* indeed resemble his portraits of Christ. The downcast heads of dejected individuals (plates 4, 5, 12, 18, 22, and 24) echo the bowed head of Christ in agony (plates 1, 2, 3, 21, and 35). Upon contemplation, the former begin to resemble and partake of the Passion of Christ. Similarly, the scenes of poor mothers and their children (plates 10, 13, and 42) parallel Rouault's rendering of the Virgin and Child (plate 56).

As the *Miserere* figures fully accept and are immersed in misery, as the way of meeting Christ in his suffering, Christ in response partakes of their agonies himself. He is not the Christ of the past, but of the present, perennially in Passion to atone for the sins of mankind, as well as to experience himself the immediate pains of individual men and women. Thus, he is "eternally flagellated" (plate 3), "in agony until the end of the world" as he remains on the cross (plate 35), and Veronica, "with her soft linen, still walks" the Via Dolorosa in expectation of Christ's appearance (plate 33). Christ's image occurs throughout the *Miserere* portfolio, participating in scenes of the distressed and scenes of the dying. But he is not just *there*, he is also the ultimate recipient of all pain. As Bloy declared, "Jesus is at the center of everything, he accepts everything, he carries everything, he suffers everything. It is impossible to strike another without striking him, to humiliate someone without humiliating him, to malign or kill without maligning or killing Christ himself."[29] As people suffer, Christ suffers too, and so, for both Bloy and Rouault, Christ was a living reality. Indeed, the latter professed, "I believe, in such hazardous times, only in Jesus on the Cross. . . . He alone, bleeding Jesus, was willing to

hear me."[30] Christ is thus the source of all comfort, as he is there at all times throughout the journey of life, and especially in the thick of suffering.

In the immediate present, this association with Christ through the medium of suffering is the door to Heaven. Through suffering, one becomes intimately connected to Christ. Partaking of his divine body, one thereby experiences the supernatural world of eternity with God. The message of redemption in the *Miserere* is evident even in the scenes of death, such as plate 28. Yet heaven is not just something in the distant future, it becomes a present reality through being linked to Christ. Rouault first came to know of Bloy when he read his novel *La femme pauvre* (1897; The Poor Woman). Rouault was so touched by the book that he eagerly sought out its author, and their subsequent meeting in 1905 was the beginning of a lifelong friendship. In the novel, the protagonist, Clothilde, faces innumerable trials and miseries, including the death of her husband and child, and is finally reduced to living the life of a beggar. At this point, a priest approaches her offering consolation, but her response is rather unexpected. "'You must be unhappy, my poor woman,' said he, a priest who had seen her full of tears. . . . 'I am perfectly happy,' said she. 'One does not enter Paradise tomorrow, nor the day after tomorrow, nor in ten years, one enters there "today," when one is poor and crucified.'"[31] This is not to say that one should seek suffering or glorify suffering. Rouault seems to have agreed with Bloy that through suffering, one becomes the recipient of grace, able to taste, in the here and now, heaven on earth through the living body of Christ. It is not the dream of a better tomorrow, but the actual presence of Christ in the Passion that brings the true hope of Heaven to the lives of the afflicted. For Rouault, the image of the suffering Christ is the answer to pain, sin, and death — a living hope in the midst of all misery.

Two of Rouault's closest friends found just such messages of grace in his works depicting the downtrodden and the dejected. The renowned philosopher Jacques Maritain, who wrote frequently on Rouault's work, declared that the artist had discovered the image of the Lamb of God in all of those who have been abandoned and rejected, for whom he felt such great compassion.[32] The poet André Suarès wrote to Rouault that his work, recalling as it does stained glass windows (even the black-and-white prints, with their glowing whites, shimmering gray backdrops, and stark black outlines), serves as an emblem of grace and salvation to those in distress:

I love this manner and this flavor of redemption that you pursue sometimes, and which sometimes you carry into hell. This is what draws your rogues, your women, your wretches, and your monsters of horror and of the mud: the beautiful style with which you have dressed them is a guarantee of their souls, and that their misery is worthy of salvation.[33]

The *Miserere* can be seen as the culmination of all of the thematic images that Rouault developed over the years. What makes it different is that these images are now gathered

together to show their interrelationships. Rouault's types should be viewed together, as they all originate from the same source: Rouault's compassion for mankind and his desire to bring redemption to this fallen world. The *Miserere* makes the connection more easily, juxtaposing the images of the poor, the bourgeoisie, and Christ to demonstrate their contemporary relevance in light of suffering and grace. The portfolio, although originating out of Rouault's reaction to World War I and the death of his father, is a testament to his lifelong views on suffering. It is, however, ultimately a book of hope, constantly pointing to the answer to the world's troubles. In the *Miserere*, the very question that is raised about suffering through its various images and scenes is the answer itself. Suffering is what binds all of these figures together — man's fall is the reason for all of the misery, yet suffering is also the key to salvation.

Rouault found both pity and grace "in the deep furrow." "Sillon," the French word for furrow, has a depth of meaning. In addition to the literal meaning of a furrow, as in deep wrinkles on a face or the rows plowed when sowing, it also implies the inexpressible misery that lies beyond physical pain and the tangible. Words are not adequate to explain this sublime suffering; it is something seen, perhaps, in the self-portraits of the wrinkled, aged Rembrandt, whose eyes speak of weariness and resignation, of a life of long suffering. It is that suffering that Rouault speaks to, when he claims to be a friend of those in the deep furrow. The *Miserere*, too, speaks of that "sillon," not just of immediate physical pain and the sorrows brought on by war, death, and poverty. It speaks as well of the perennial miseries that are part of man's lot, the intrigues, disasters, murders, and myriad sins and treacheries that fill the annals of human history. Rouault meant the work to summarize these sufferings on a level that is almost supernatural — the *Miserere* becomes a work of "sillon," whose true creator and bearer is Christ himself. So, it is addressed to him, asking him to meet mankind in the "sillon," to grant grace and salvation to us in the very heart of our affliction and misery. For Rouault, the *Miserere* became a prayer book of hope.

Soo Yun Kang
Associate Professor of Art History, Chicago State University

[1] Georges Rouault, *Soliloques*, foreword by Claude Roulet (Neuchâtel [Zurich: Orell Füssli arts graphiques, s.a.], 1944), 47.

[2] "Je suis né ouvrier, dans un quartier ouvrier." Florent Fels, "Rouault," *Les nouvelles littéraires* (15 March 1923): 4. All translations from the French are the author's.

[3] Rouault to Jacques and Raïssa Maritain, 15 January 1946, in Georges Rouault, *Sur l'art et sur la vie*, preface by Bernard Dorival (Paris: Denoël, 1971), 198.

[4] Ibid., 201.

[5] In the preface to the 1948 publication of the *Miserere*, Rouault stated that the first versions of most of the plates date from 1914–18. François Chapon uncovered several sources documenting the fact that Rouault began working on the earliest drawings for the series in 1912, following the death of his father. See Chapon and Isabelle Rouault, *Rouault: oeuvre gravé*, 2 vols. (Monte-Carlo: A. Sauret, 1978), 1: 70. For a thorough treatment of all of the plates in the *Miserere* series, including study pieces and rejected plates, see 1: 194–319.

[6] The long process from conception to actual publication was the result of Rouault's many tangles with Vollard, as well as subsequent legal complications with Vollard's heirs. See Chapon and Rouault, *Rouault: oeuvre gravé*, 1: 73–75.

[7] According to the dates on the plates, twenty-four were completed in 1922, thirteen in 1923, fourteen in 1926, and six in 1927. See *Rouault: oeuvre gravé*, 1: 73–74.

[8] Plate 20 is at home in both the "court scenes" and the "Christ" groupings.

[9] The legend of St. Veronica comes from the apocryphal Gospel of Nicodemus; it describes a compassionate woman who wiped the sweat from Jesus's brow with her veil or handkerchief, as the Savior was on the way to his death at Golgotha. Miraculously, Veronica's veil retains a permanent imprint of Christ's face.

[10] For Rouault's paintings of the poor from the second decade of the twentieth century, see Bernard Dorival and Isabelle Rouault, *Rouault, l'oeuvre peint*, 2 vols. (Monte-Carlo: André Sauret, 1988), 1: 131–53.

[11] "Au rude hiver / Haï des pauvres gens." Rouault, *Soliloques*, 182.

[12] "Va vielle mère / Voici l'hiver / Le ciel est bas / Le temps gris / L'âme lourde. . . . Va vieille mère / Tout est misère / Aux pauvres gens. / A ceux qui n'ont pour tout bien / Que leurs deux bras / Tout est misère / En temps de paix / Et plus encore de guerre / Tout est misère." Rouault, *Soliloques*, 184–85.

[13] For the "Wrestler" and "Acrobat" figures of 1913, see Dorival, *Rouault, l'oeuvre peint*, 1: 152.

[14] "Cette voiture de nomads, arrêtée sur la route, le vieux cheval étique qui paît l'herbe maigre, le vieux pitre assis au coin de sa roulotte en train de repriser son habit brillant et bariolé, ce contraste de choses brilliantes, scintillantes, faites pour amuser et cette vie d'une tristesse infinie. . . . J'ai vu clairement que le 'Pitre' c'était moi, c'était nous. . . . Cet habit riche et pailleté c'est la vie qui nous le donne, nous sommes tous des pitres plus ou moins, nous portons tous un 'habit pailleté' mais si l'on nous surprend comme j'ai surpris le vieux pitre, oh! alors qui osera dire qu'il n'est pas pris jusqu'au fond des entrailles par une incommensurable pitié. J'ai le défaut (défaut peut-être . . . en tout cas c'est pour moi un abîme de souffrances. . . .) 'de ne laisser jamais à personne son habit pailleté,' fût-il roi ou empereur. L'homme que j'ai devant moi, c'est son

âme que je veux voir . . . et plus il est grande et plus on le glorifie humainement et plus je crains pour son âme." Published in *Le goéland* (June 1952); reprinted in Rouault, *Sur l'art et sur la vie*, 171–72.

15 See Bloy's 1887 novel, *Les désespéré* (The Desperate Ones); reprinted in Bloy, *Oeuvres*, 15 vols., edited by Joseph Bollery and Jacques Petit (Paris: Mercure de France, 1964–75), 3: 307–8.

16 Rouault executed several other portraits of bourgeois women that are accompanied by the same phrase. See Dorival, *Rouault, l'oeuvre peint*, 1: 207.

17 Auguries means *omens*.

18 "Ils [Catholics] ont l'horreur de toute action." Rouault to Auguste Marguillier, 1904, in Waldemar George and Geneviève Nouaille-Rouault, *L'univers de Rouault* (Paris: H. Scrépel, 1971), 65–66.

19 "On ne donnait pas cher de ma carcasse, et bonnes gens . . . ne parlaient que d'Assurances sur la vie en me fixant d'un oeil inquiet." Rouault to Jacques and Raïssa Maritain, 15 January 1946, in Rouault, *Sur l'art et sur la vie*, 79.

20 See Chapon, *Rouault: oeuvre gravé*, 1: 122.

21 Reprinted in Alfred Jarry, *Oeuvres complètes*, 3 vols., edited by Henri Bordillon et al. (Paris: Gallimard, 1972–88), 1: 416–17.

22 Pierre Courthion, *Georges Rouault. Including a Catalogue of Works Prepared with the Collaboration of Isabelle Rouault* (New York: H.N. Abrams, 1962), 145.

23 "Le condemné s'en est allé / indifférent et fatigué / son avocat en phrases creuses / et imposantes / a proclamé son innocence / un homme rouge tonitruant / et se dressant / a disculpé la Société / et chargé l'accusé / sous un Jésus en croix / oublié là." Rouault, *Paysages legendaries* (Paris: Porteret, 1929); reprinted in Rouault, *Sur l'art et sur la vie*, 153–54. "The man in red" is the presiding judge in the typical red robes that all French judges wore at the time.

24 According to Bernard Dorival, Rouault conceived the *Fleurs du mal* series around 1920; see Dorival, *Rouault, l'oeuvre peint*, 1: 273.

25 "La mort l'a pris / quand il sortit / du lit d'orties / où il dormit / toute sa vie. / Demain sera beau / chantait-il tout en pleurs / tenant son coeur / avec ferveur / comme une sainte hostie / Devant lui / la route bénie / où les Elus de l'Esprit / ont passé / tout sanglants et éblouis / Il arrivait enfin! / la porte de la maison s'ouvrait / sans crier sur ses gonds / c'était là le havre de grace / Personne ne lui demandait / sa dernière residence / son acte de naissance / ni où il faudrait aller / dès le soleil levé." Rouault, "Trois petits poèmes," *Les soirées de Paris* 26/27 (1914); reprinted in Rouault, *Sur l'art et sur la vie*, 146–47.

26 "Ils n'ont jamais compris le fond de ma pensée envers cette humanité que je parais bafouer." Rouault, *Soliloques*, 56.

27 "Je suis l'ami silencieux de ceux qui peinent dans le sillon creux, je suis le lierre de la misère éternelle qui s'attache sur le mur lépreux derrière lequel l'humanité rebelle cache ses vices et ses vertus." Georges Charensol, *Georges Rouault, le homme et l'oeuvre* (Paris: Éditions des quatre chemins, 1926), preface.

28 Léon Bloy, *Dans les ténèbres* (1918); reprinted in Bloy, *Oeuvres*, 9: 306–8.

29 "Jésus est au center de tout, il assume tout, il porte tout, il souffre tout. Il est impossible de frapper un être sans le frapper, d'humilier quelqu'un sans l'humilier, de maudire ou de tuer qui que ce soit sans le madire ou le tuer lui-même." Journal entry, 3 December 1894, in Bloy, *Oeuvres*, 11: 158.

30 "Je ne crois, dans des temps si hasardeux, qu'à Jésus sur la Croix. . . . Seul, Jésus sanglant a bien voulu m'entendre." Charensol, *Georges Rouault, le homme et l'oeuvre*, preface.

[31] "'Vous devez être bien malheureuse, ma pauvre femme,' lui disait un prêtre qui l'avait vue tout en larmes. . . . 'Je suis parfaitement heureuse,' répondit-elle. 'On n'entre pas dans le Paradis demain, ni après-demain, ni dans dix ans, on y entre "aujourd'hui," quand on est pauvre et crucifié.'" Bloy, *Oeuvres*, 7: 268.

[32] Jacques Maritain, "Georges Rouault," *La revue universelle* 17 no. 4 (15 May 1924); reprinted in Jacques and Raïssa Maritain, *Oeuvres complètes*, 16 vols. (Fribourg, Suisse: Editions universitaires; Paris: Editions Saint-Paul, 1982–99), 5: 762–64.

[33] "J'aime cette manière et ce goùt de rédemption que tantôt vous poursuivez, et tantôt vous portez dans l'enfer. Voilà ce qui tire vos gueux, vos filles, vos misérables et tous vos monstres de l'horreur et de la fange: la belle matière dont vous les avez revêtus est garante de leur âme, et que leur misère est digne aussi du salut." Suarès to Rouault, 19 December 1923, in Georges Rouault and André Suarès, *Correspondance [de] Georges Rouault [et] André Suarès*, introduction by Marcel Arland (Paris: Gallimard, 1960), 184.

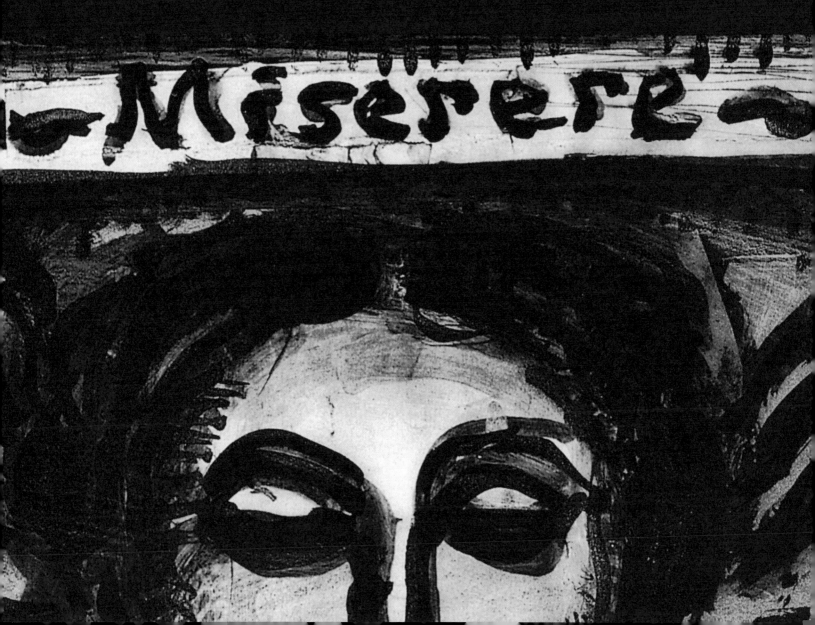

plate 1

Have mercy upon me, O God, according to thy loving-kindness.

Miserere mei, Deus, secundum magnam misericordiam tuam.

Have mercy upon me, O God, according to thy loving-kindness: according unto the multitude of thy tender mercies blot out my transgressions. Wash me thoroughly from mine iniquity, and cleanse me from my sin. For I acknowledge my transgressions: and my sin is ever before me. Against thee, thee only, have I sinned, and done this evil in thy sight: that thou mightest be justified when thou speakest, and be clear when thou judgest. Behold, I was shapen in iniquity; and in sin did my mother conceive me. Behold, thou desirest truth in the inward parts: and in the hidden part thou shalt make me to know wisdom. Purge me with hyssop, and I shall be clean: wash me, and I shall be whiter than snow.

PSALM 51:1–7

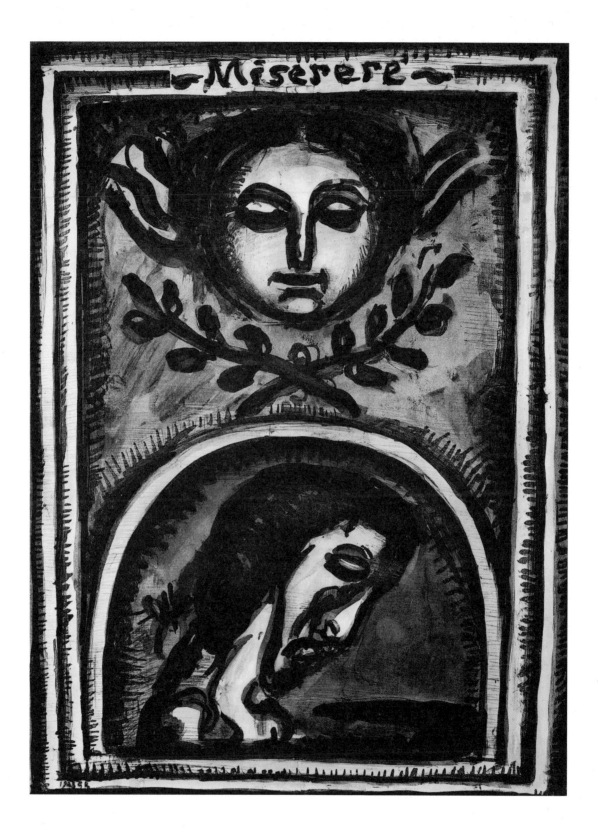

plate 2

Jesus despised . . .

Jésus honni . . .

For even hereunto were ye called: because Christ also suffered for us, leaving us an example, that ye should follow his steps: who did no sin, neither was guile found in his mouth: who, when he was reviled, reviled not again; when he suffered, he threatened not; but committed himself to him that judgeth righteously: who his own self bare our sins in his own body on the tree, that we, being dead to sins, should live unto righteousness: by whose stripes ye were healed.

I Peter 2:21–24

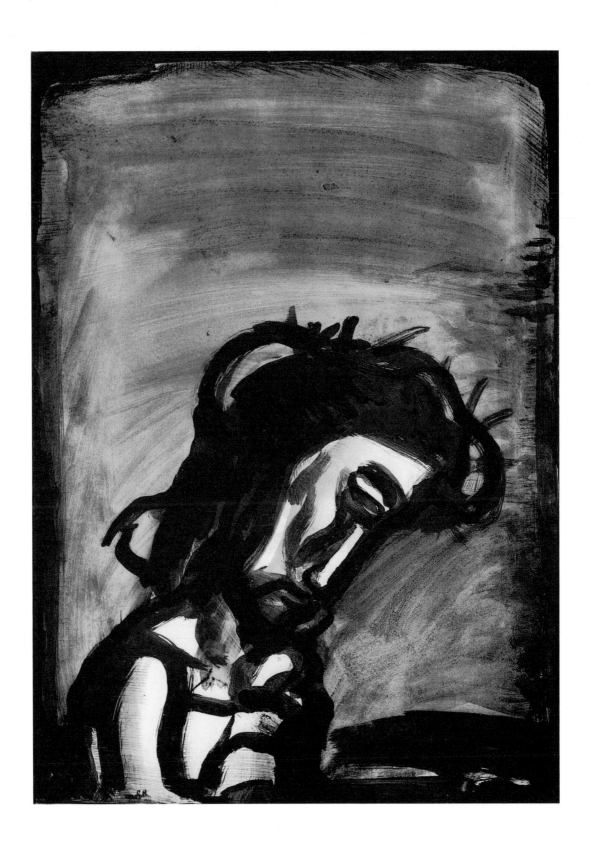

plate 3

eternally flagellated . . .

toujours flagellé . . .

Then Pilate therefore took Jesus, and scourged him. And the soldiers platted a crown of thorns, and put it on his head, and they put on him a purple robe, and said, Hail, King of the Jews! and they smote him with their hands.

JOHN 19:1–3

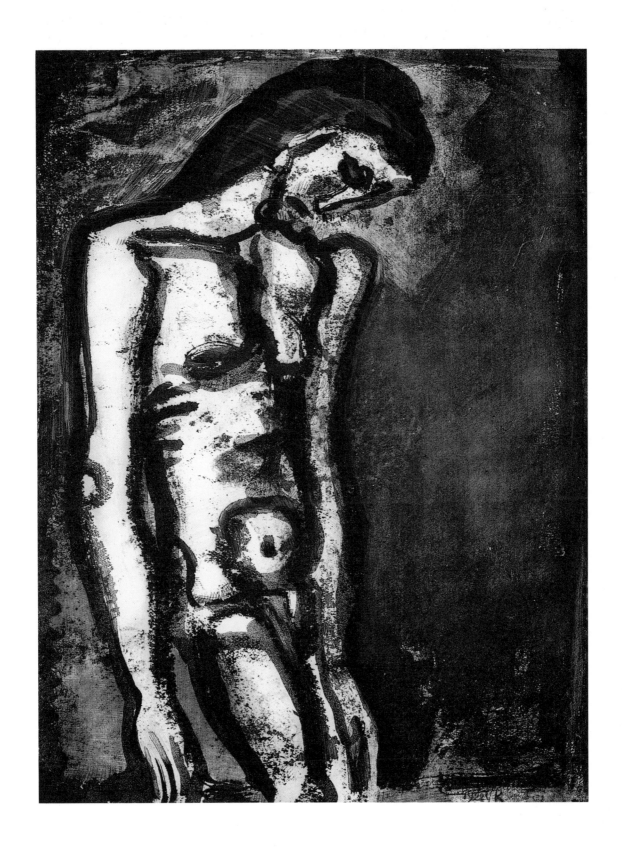

plate 4

take refuge in your heart, vagabond of misfortune.

se réfugie en ton coeur, va-nu-pieds de malheur.

My God will cast them away, because they did not hearken unto him: and they shall be wanderers among the nations.

HOSEA 9:17

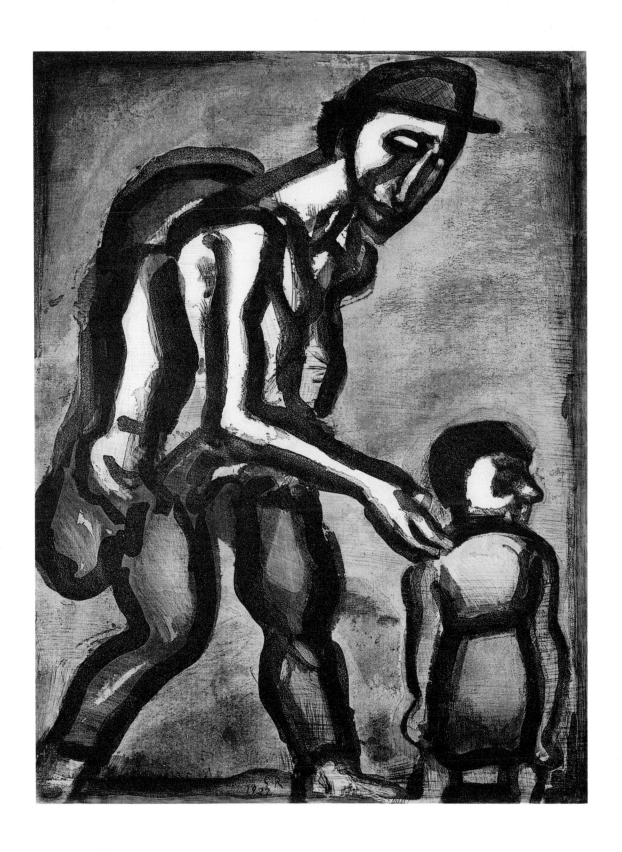

plate 5

Lonely, in this life of pitfalls and malice.

Solitaire, en cette vie d'embûches et de malices.

He sitteth alone and keepeth silence, because he hath borne it upon him. He putteth his mouth in the dust; if so be there may be hope. He giveth his cheek to him that smiteth him: he is filled full with reproach. For the Lord will not cast off for ever: but though he cause grief, yet will he have compassion according to the multitude of his mercies. For he doth not afflict willingly, nor grieve the children of men.

LAMENTATIONS 3:28–33

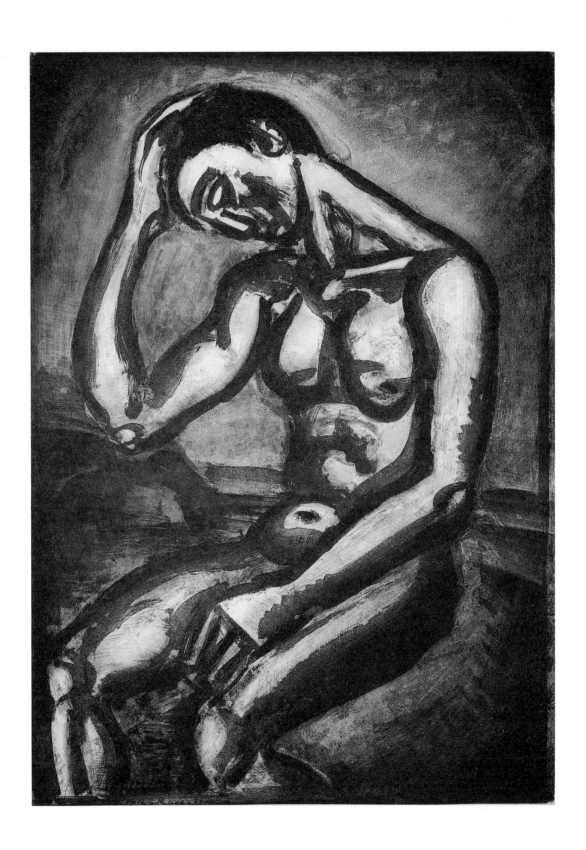

plate 6

Are we not convicts?

Ne sommes-nous pas forçats?

Thus saith the Lord, In an acceptable time have I heard thee, and in a day of salvation have I helped thee: and I will preserve thee, and give thee for a covenant of the people, to establish the earth, to cause to inherit the desolate heritages; that thou mayest say to the prisoners, Go forth; to them that are in darkness, Shew yourselves. They shall feed in the ways, and their pastures shall be in all high places. They shall not hunger nor thirst; neither shall the heat nor sun smite them: for he that hath mercy on them shall lead them, even by the springs of water shall he guide them.

Isaiah 49:8–10

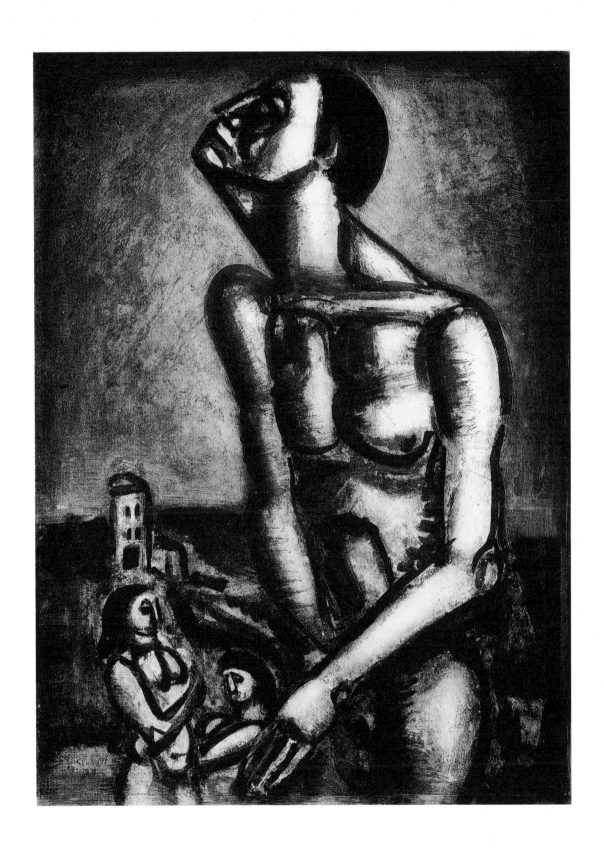

plate 7

believing ourselves kings.

nous croyant rois.

Better is a poor and a wise child than an old and foolish king, who will no more be admonished. For out of prison he cometh to reign; whereas also he that is born in his kingdom becometh poor.
ECCLESIASTES 4:13–14

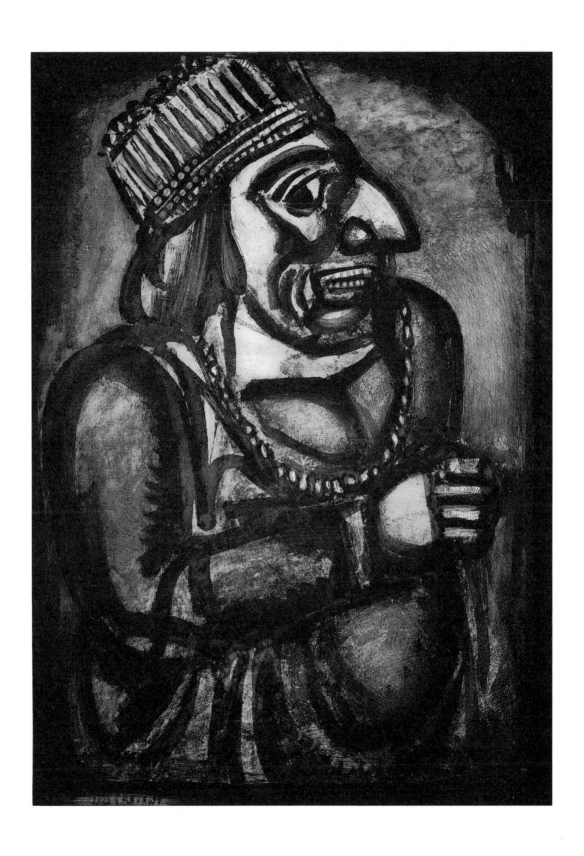

plate 8

Who does not put on make-up?

Qui ne se grime pas?

I am weary of my crying: my throat is dried: mine eyes fail while I wait for my God. They that hate me without a cause are more than the hairs of mine head: they that would destroy me, being mine enemies wrongfully, are mighty: then I restored that which I took not away. O God, thou knowest my foolishness; and my sins are not hid from thee.

PSALM 69:3–5

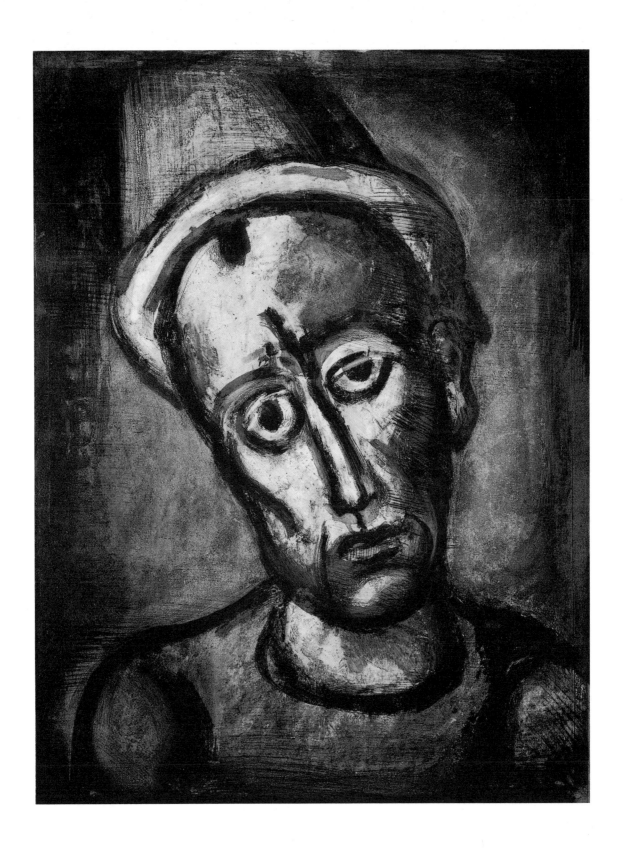

plate 9

At times the road is beautiful . . .

Il arrive parfois que la route soit belle . . .

Then shall the lame man leap as an hart, and the tongue of the dumb sing: for in the wilderness shall waters break out, and streams in the desert. And the parched ground shall become a pool, and the thirsty land springs of water: in the habitation of dragons, where each lay, shall be grass with reeds and rushes. And an highway shall be there, and a way, and it shall be called The way of holiness; the unclean shall not pass over it; but it shall be for those: the wayfaring men, though fools, shall not err therein.

ISAIAH 35:6–8

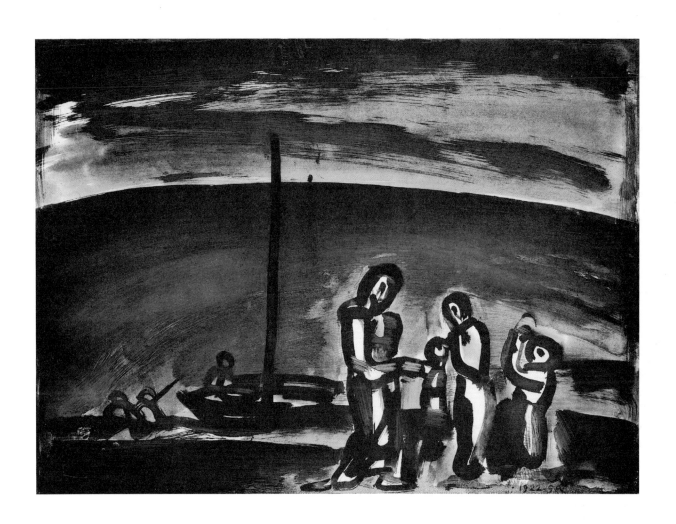

plate 10

in the old district of Long Suffering.

au vieux faubourg des Longues Peines.

Who comforteth us in all our tribulation, that we may be able to comfort them which are in any trouble by the comfort, wherewith we ourselves are comforted of God. For as the sufferings of Christ abound in us, so our consolation also aboundeth by Christ.

2 Corinthians: 1:4–5

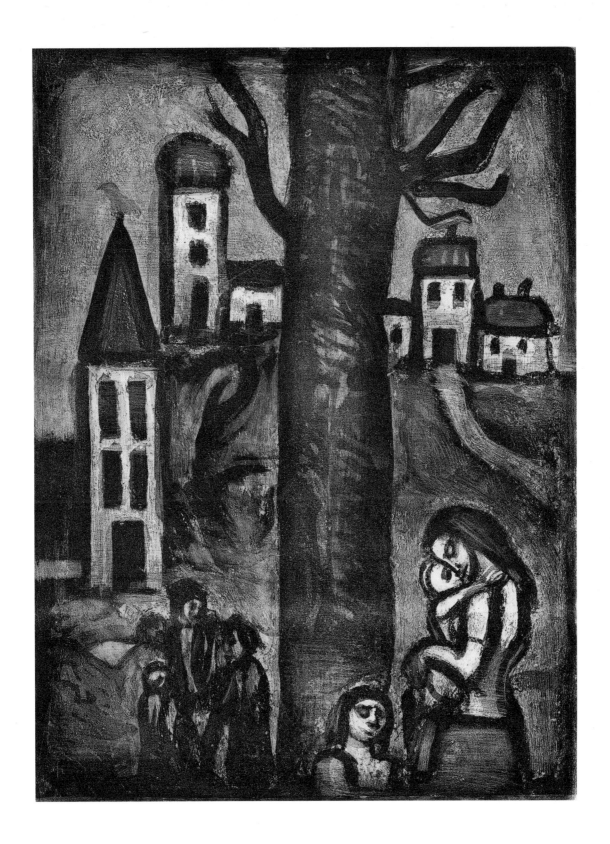

plate 11

Tomorrow will be beautiful, said the shipwrecked man.

Demain sera beau, disait le naufragé.

The Spirit of the Lord God is upon me; because the Lord hath anointed me to preach good tidings unto the meek; he hath sent me to bind up the brokenhearted, to proclaim liberty to the captives, and the opening of the prison to them that are bound.... To appoint unto them that mourn in Zion, to give unto them beauty for ashes, the oil of joy for mourning, the garment of praise for the spirit of heaviness; that they might be called trees of righteousness, the planting of the Lord, that he might be glorified.
ISAIAH 61:1, 3

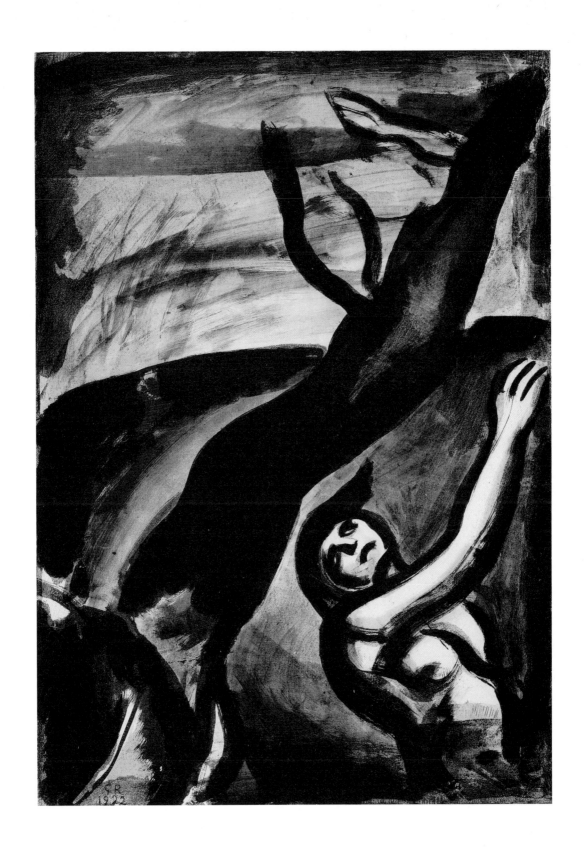

plate 12

The hard work of living . . .

Le dur métier de vivre . . .

And unto Adam he said, Because thou hast hearkened unto the voice of thy wife, and hast eaten of the tree, of which I commanded thee, saying, Thou shalt not eat of it: cursed is the ground for thy sake; in sorrow shalt thou eat of it all the days of thy life; thorns also and thistles shall it bring forth to thee; and thou shalt eat the herb of the field; in the sweat of thy face shalt thou eat bread, till thou return unto the ground; for out of it wast thou taken: for dust thou art, and unto dust shalt thou return.

GENESIS 3:17–19

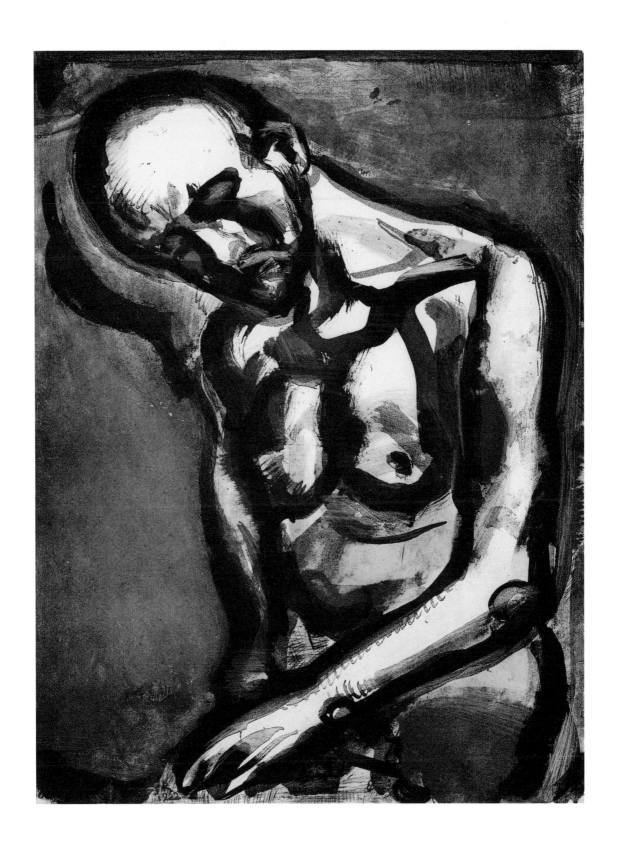

plate 13

it would be so sweet to love.

il serait si doux d'aimer.

Ye have heard that it hath been said: Thou shalt love thy neighbor, and hate thine enemy. But I say unto you, Love your enemies, bless them that curse you, do good to them that hate you, and pray for them which despitefully use you, and persecute you; that ye may be the children of your Father which is in heaven: for he maketh his sun to rise on the evil and on the good, and sendeth rain on the just and on the unjust. For if ye love them which love you, what reward have ye? do not even the publicans the same?

MATTHEW 5:43–46

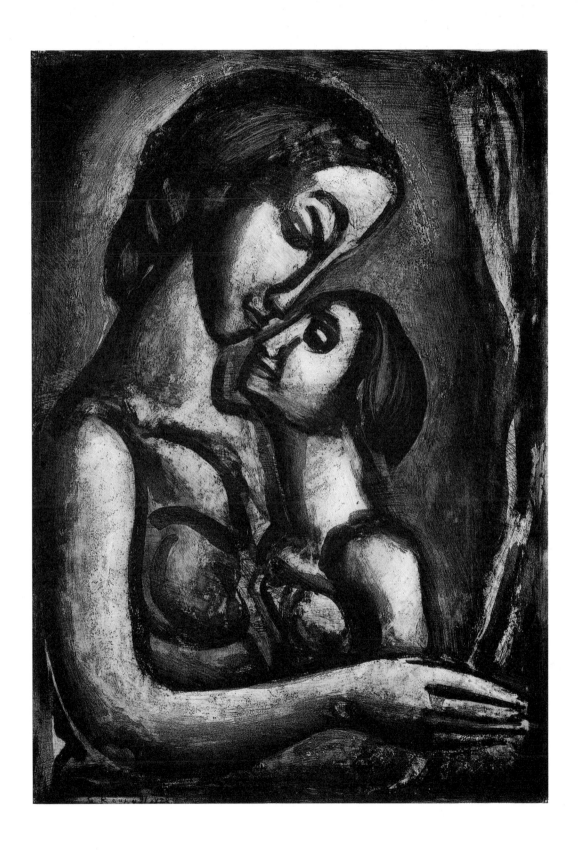

plate 14

A young woman called joy.

Fille dite de joie.

And the scribes and Pharisees brought unto him a woman taken in adultery; and when they had set her in the midst, they say unto him, Master, this woman was taken in adultery, in the very act. Now Moses in the law commanded us, that such should be stoned: but what sayest thou? This they said, tempting him, that they might have to accuse him. But Jesus stooped down, and with his finger wrote on the ground, as though he heard them not. So when they continued asking him, he lifted up himself, and said unto them, He that is without sin among you, let him first cast a stone at her.
John 8:3–7

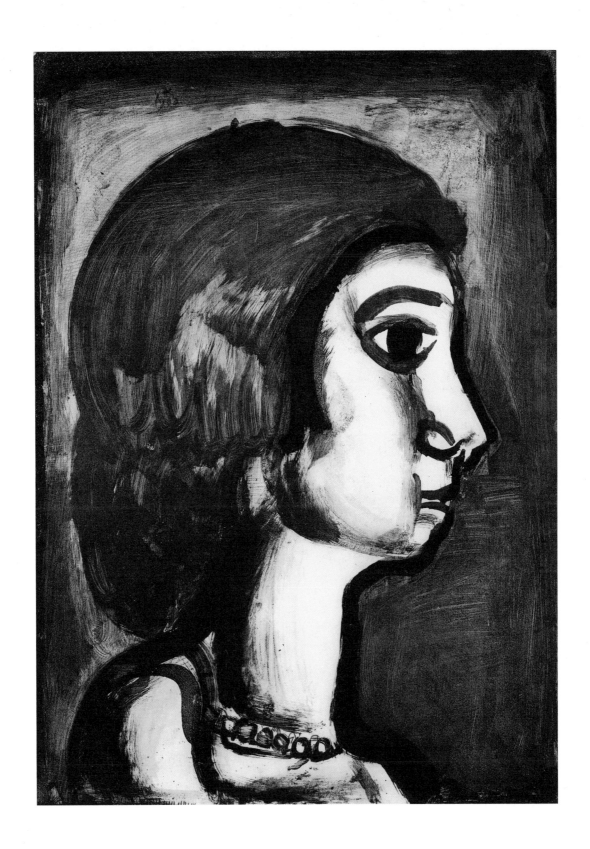

plate 15

In a mouth which was once fresh, the taste of bitterness.

En bouche qui fut fraîche, goût de fiel.

And I said, My strength and my hope is perished from the Lord: remembering mine affliction and my misery, the wormwood and the gall. My soul hath them still in remembrance, and is humbled in me. This I recall to my mind, therefore have I hope. It is of the Lord's mercies that we are not consumed, because his compassions fail not. They are new every morning: great is thy faithfulness.

LAMENTATIONS 3:18–23

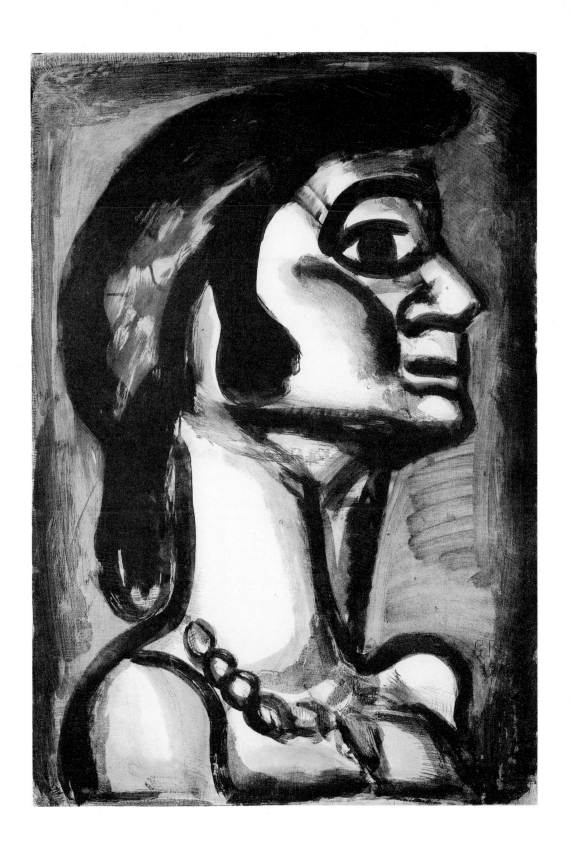

plate 16

The upper class lady believes she holds a reserved seat in Heaven.

Dame du Haut-Quartier croit prendre pour le Ciel place réservee.

The pride of thine heart hath deceived thee, thou that dwellest in the clefts of the rock, whose habitation is high; that saith in his heart, Who shall bring me down to the ground? Though thou exalt thyself as the eagle, and though thou set thy nest among the stars, thence will I bring thee down, saith the Lord.

OBADIAH 1:3–4

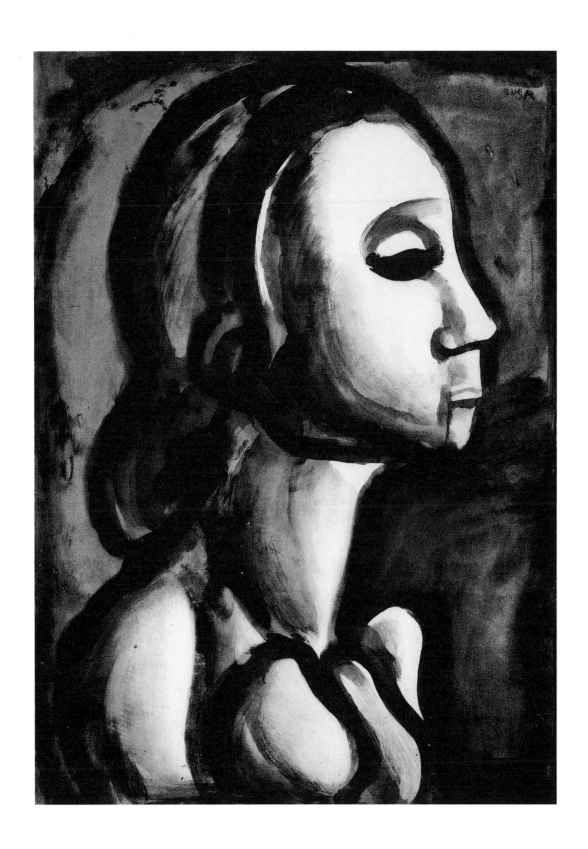

plate 17

An emancipated woman, at two o'clock, sings noon.

Femme affranchie, à quatorze heures, chante midi.

The Lord shall smite thee with madness, and blindness, and astonishment of heart: and thou shalt grope at noonday, as the blind gropeth in darkness, and thou shalt not prosper in thy ways: and thou shalt be only oppressed and spoiled evermore, and no man shall save thee.

DEUTERONOMY 28:28–29

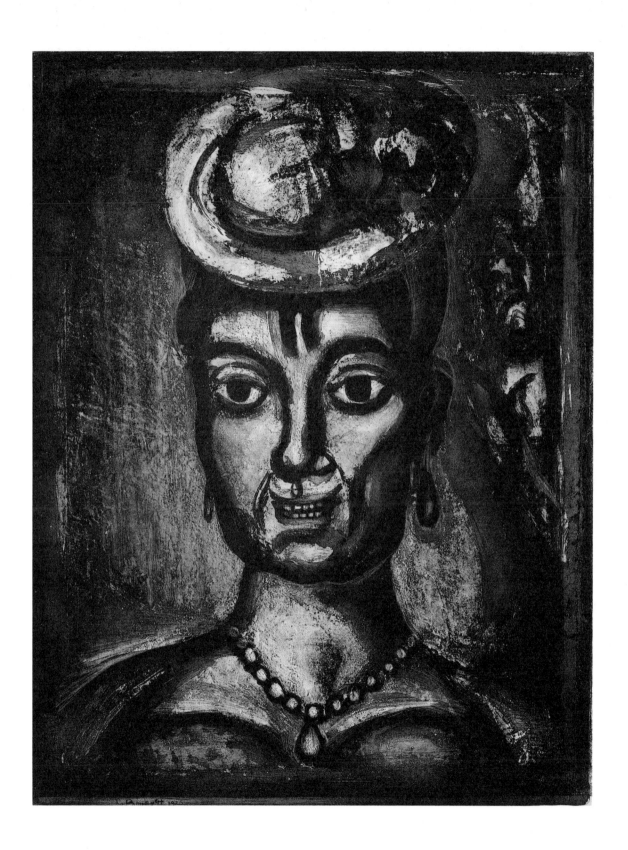

plate 18

The condemned man has gone away . . .

Le condamné s'en est allé . . .

But if ye had known what this meaneth, I will have mercy, and not sacrifice, ye would not have condemned the guiltless.

Matthew 12:7

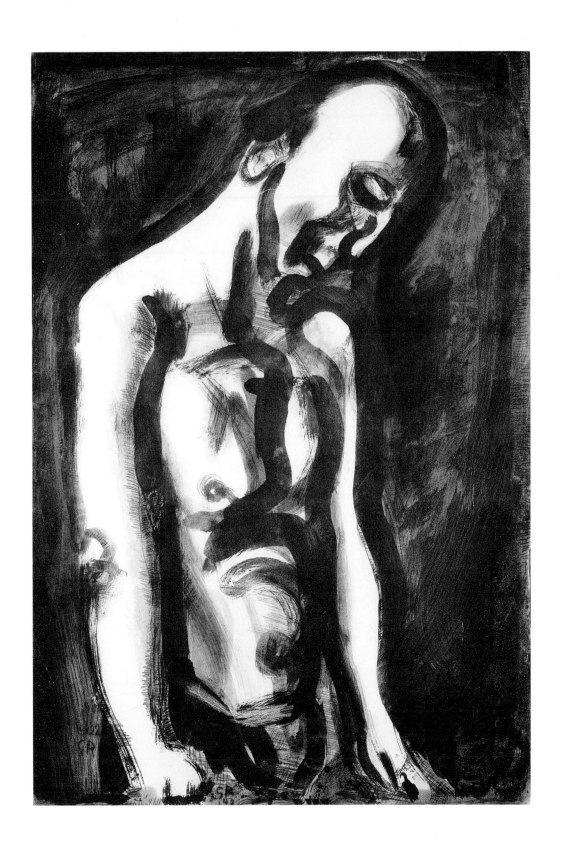

plate 19

his lawyer, in hollow phrases, proclaims his complete unconsciousness . . .

son avocat, en phrases creuses, clame sa totale inconscience . . .

Woe unto you, scribes and Pharisees, hypocrites! for ye are as graves which appear not, and the men that walk over them are not aware of them. Then answered one of the lawyers, and said unto him, Master, thus saying thou reproachest us also. And he said, Woe unto you also, ye lawyers! for ye lade men with burdens grievous to be borne, and ye yourselves touch not the burdens with one of your fingers.

Luke 11:44–46

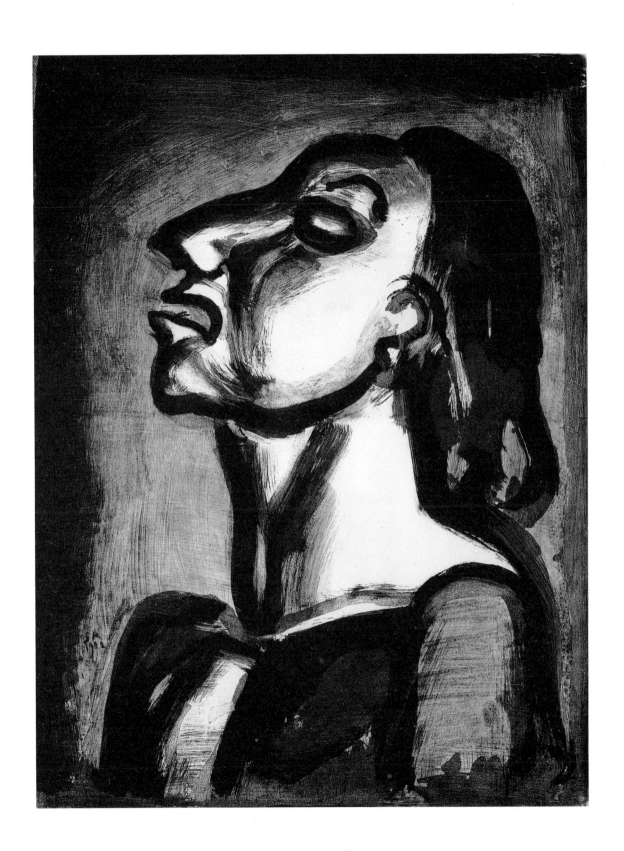

plate 20

under a Jesus on the cross forgotten there.

sous un Jésus en croix oublié là.

And at the ninth hour Jesus cried with a loud voice, saying, Elo-i, Elo-i, lama sabachthani? which is, being interpreted, My God, my God, why hast thou forsaken me?

MARK 15:34

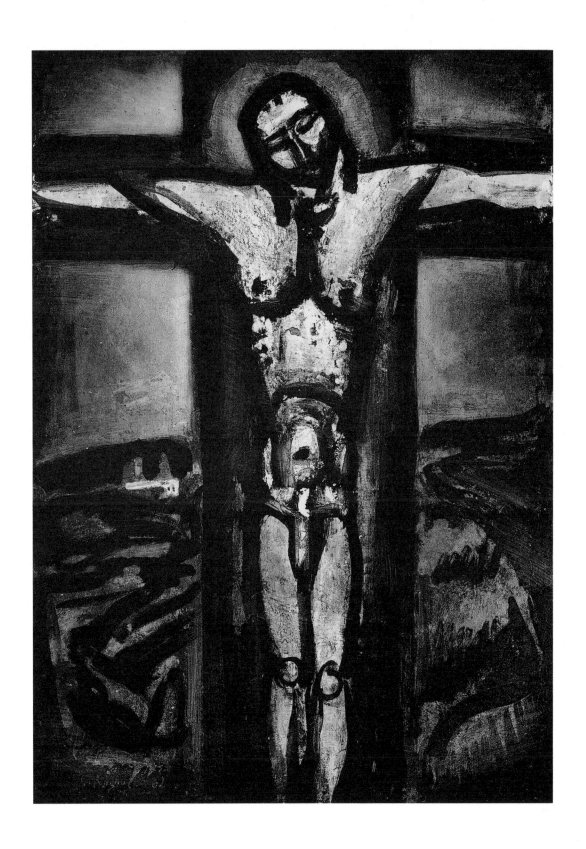

plate 21

"He was oppressed, and he was afflicted, yet he opened not his mouth."

"Il a été maltraité et opprimé et il n'a pas ouvert la bouche."

Then came Jesus forth, wearing the crown of thorns, and the purple robe. And Pilate saith unto them, Behold the man! When the chief priests therefore and officers saw him, they cried out, saying, Crucify him, crucify him. Pilate saith unto them, Take ye him, and crucify him: for I find no fault in him. The Jews answered him, We have a law, and by our law he ought to die, because he made himself the Son of God. When Pilate therefore heard that saying, he was the more afraid; and went again into the judgment hall, and saith unto Jesus, Whence art thou? But Jesus gave him no answer.

John 19:5–9

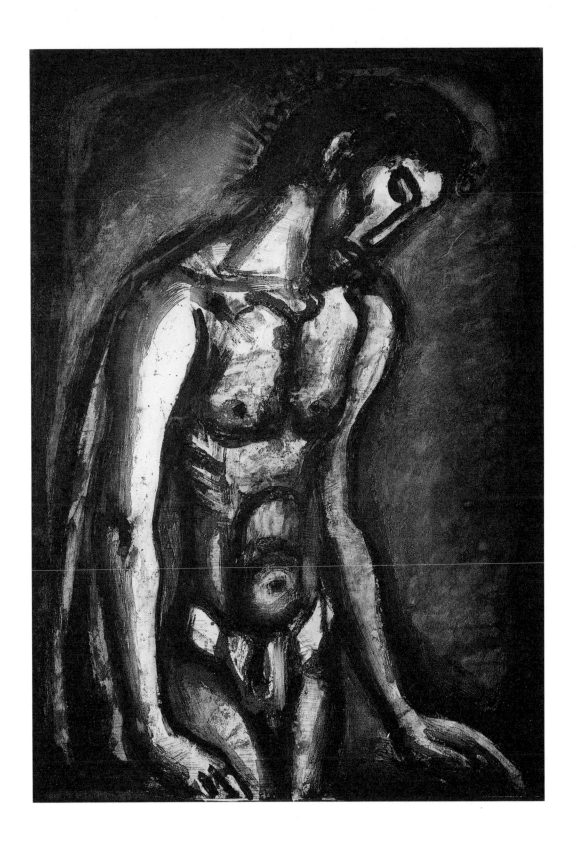

plate 22

Of so many different domains, the noble work of sowing in hostile land.

En tant d'ordres divers, le beau métier d'ensemencer une terre hostile.

He turneth rivers into a wilderness, and the watersprings into dry ground; a fruitful land into barrenness, for the wickedness of them that dwell therein. He turneth the wilderness into a standing water, and dry ground into watersprings. And there he maketh the hungry to dwell, that they may prepare a city for habitation; and sow the fields, and plant vineyards, which may yield fruits of increase.

PSALM 107:33–37

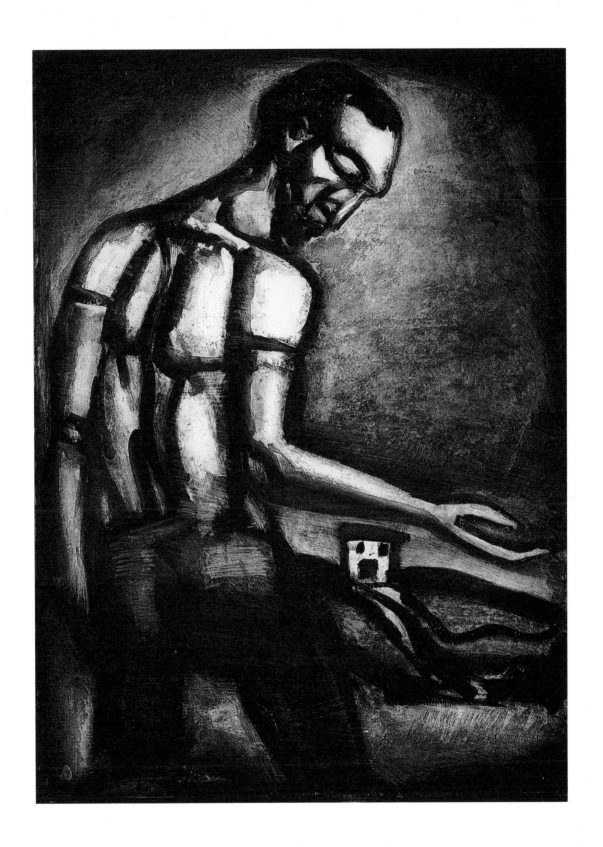

plate 23

Street of the Lonely.

Rue des Solitaires.

His remembrance shall perish from the earth, and he shall have no name in the street. He shall be driven from light into darkness, and chased out of the world.

JOB 18:17–18

plate 24

"Winter, leper of the earth."

"Hiver lèpre de la terre."

Come unto me, all ye that labour and are heavy laden, and I will give you rest. Take my yoke upon you, and learn of me; for I am meek and lowly in heart: and ye shall find rest unto your souls. For my yoke is easy, and my burden is light.
Matthew 11:28–30

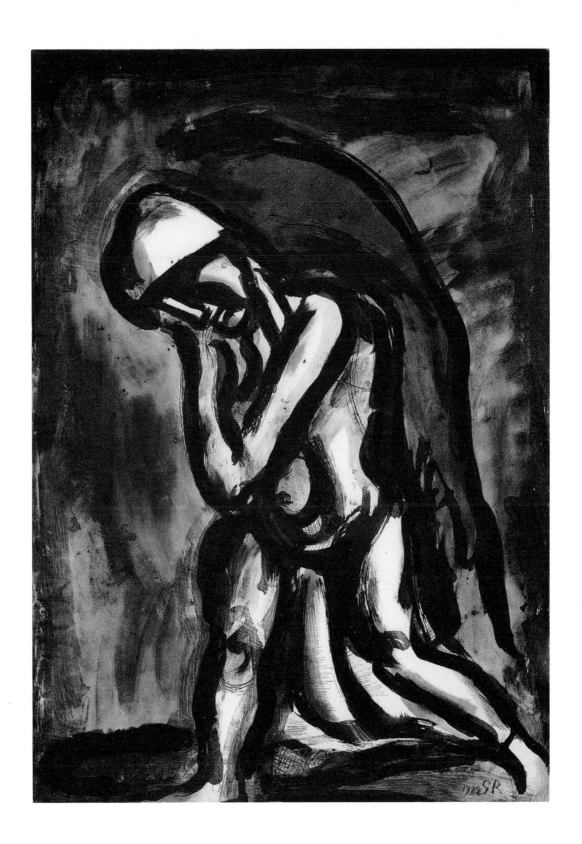

plate 25

Jean-François never sings alleluia . . .

Jean-François jamais ne chante alleluia . . .

Sing, O barren, thou that didst not bear; break forth into singing, and cry aloud, thou that didst not travail with child: for more are the children of the desolate than the children of the married wife, saith the Lord.

ISAIAH 54:1

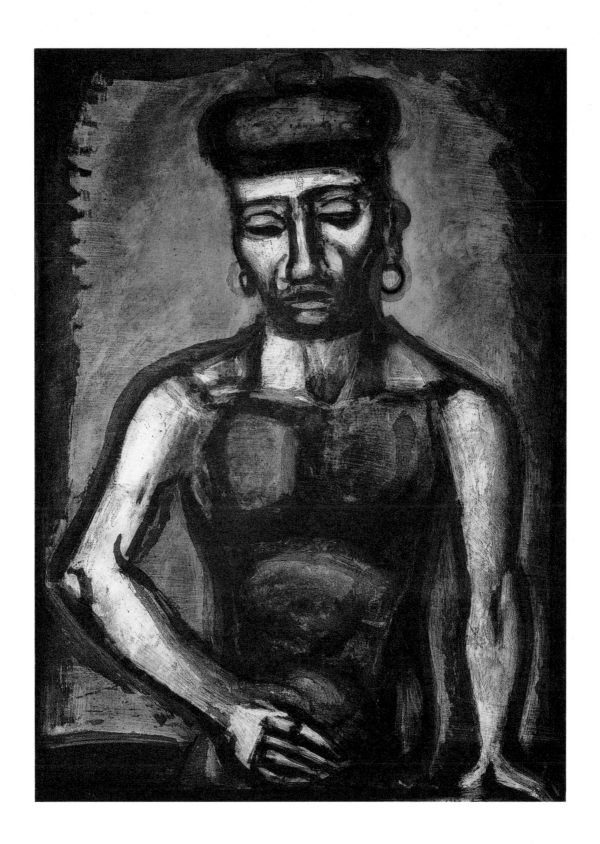

plate 26

in the land of thirst and fear.

au pays de la soif et de la peur.

They shall not hunger nor thirst; neither shall the heat nor sun smite them: for he that hath mercy on them shall lead them, even by the springs of water shall he guide them.

Isaiah 49:10

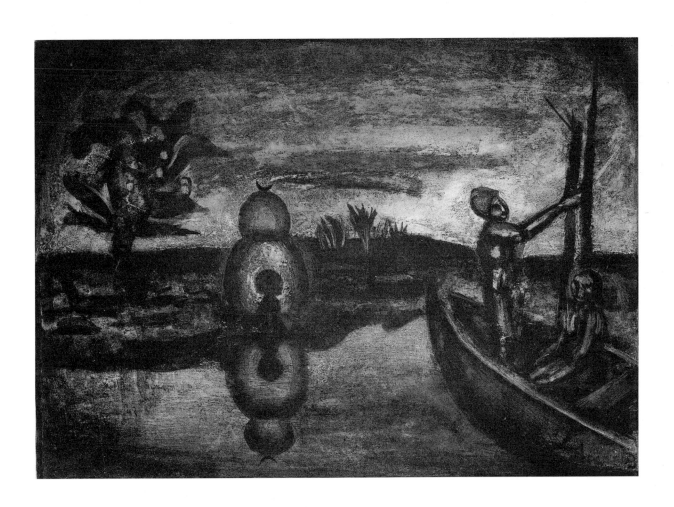

plate 27

Here are the tears of things . . .

Sunt lacrymae rerum . . .

And God shall wipe away all tears from their eyes; and there shall be no more death, neither sorrow, nor crying, neither shall there be any more pain: for the former things are passed away.

Revelation 21:4

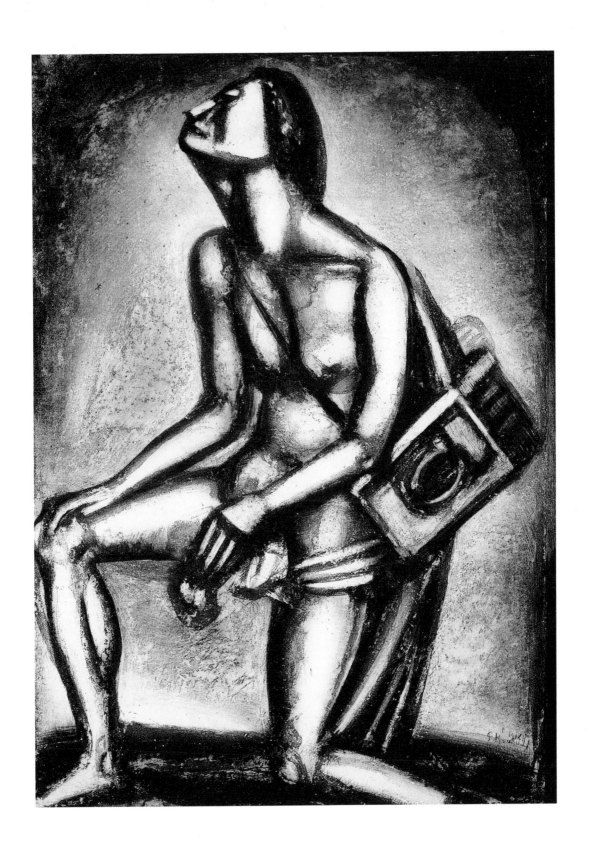

plate 28

"He that believeth in me, though he were dead, yet shall he live."

"Celui qui croit en moi, fût-il mort, vivra."

Jesus said unto her, I am the resurrection, and the life: he that believeth in me, though he were dead, yet shall he live.

John 11:25

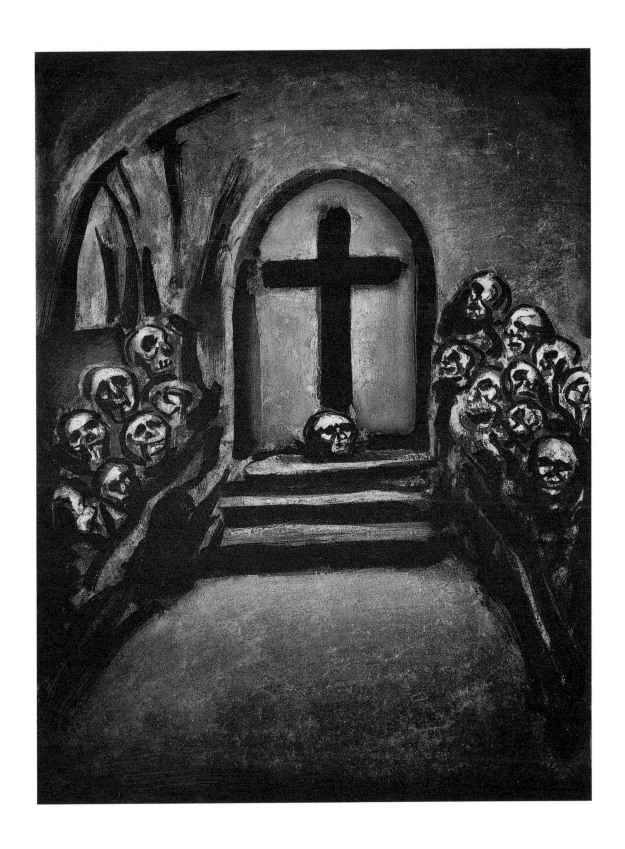

plate 29

Sing Matins, a new day is born.

Chantez Matines, le jour renaît.

For his anger endureth but a moment; in his favour is life: weeping may endure for a night, but joy cometh in the morning.

Psalm 30:5

plate 30

"We . . . were baptized into Jesus Christ, were baptized into his death."

"Nous . . . c'est en sa mort que nous avons été baptisés."

God forbid. How shall we, that are dead to sin, live any longer therein? Know ye not, that so many of us as were baptized into Jesus Christ were baptized into his death? Therefore we are buried with him by baptism into death: that like as Christ was raised up from the dead by the glory of the Father, even so we also should walk in newness of life.

ROMANS 6:2–4

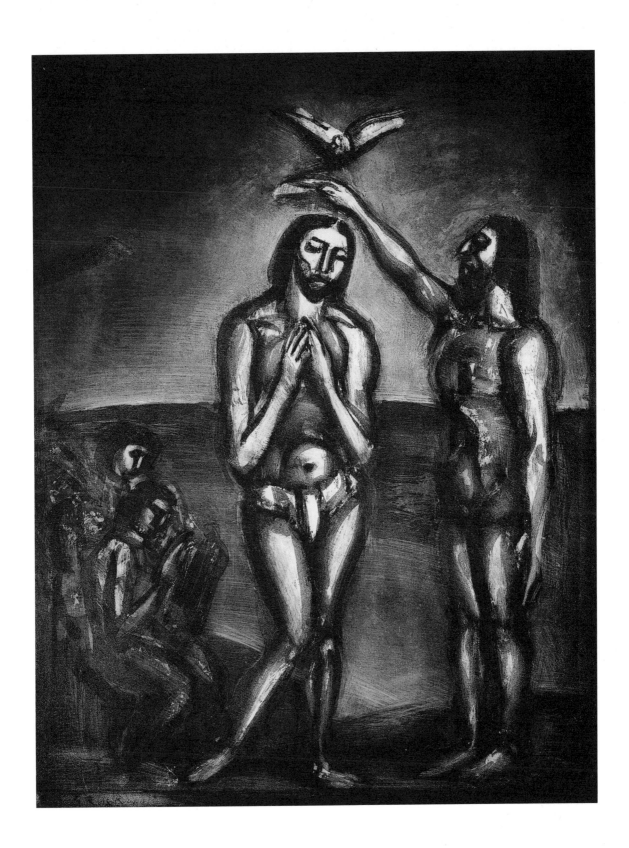

plate 31

"Love one another."

"Aimez-vous les uns les autres."

This is my commandment, That ye love one another, as I have loved you.

JOHN 15:12

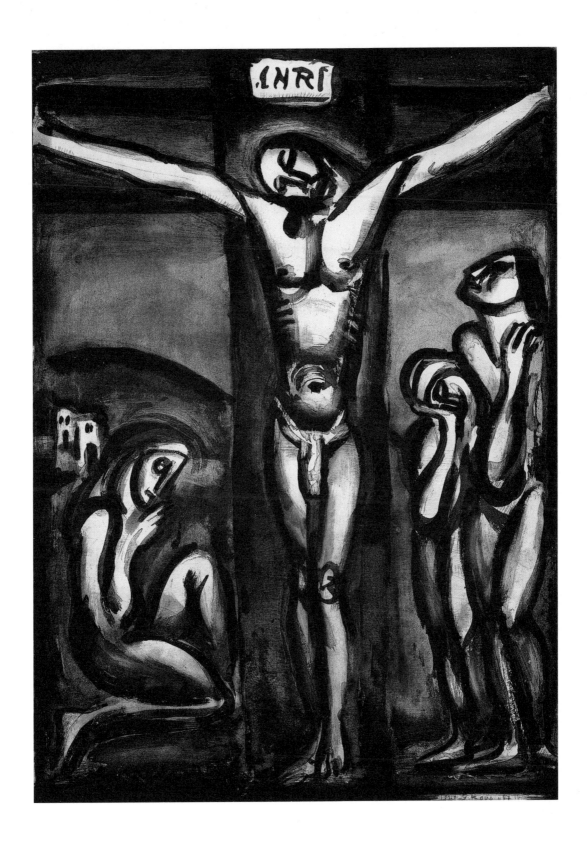

plate 32

Lord, it is you, I know you.

Seigneur, c'est vous, je vous reconnais.

Then saith he to Thomas, Reach hither thy finger, and behold my hands; and reach hither thy hand, and thrust it into my side: and be not faithless, but believing. And Thomas answered and said unto him, My Lord and my God. Jesus saith unto him, Thomas, because thou hast seen me, thou hast believed: blessed are they that have not seen, and yet have believed.

JOHN 20:27–29

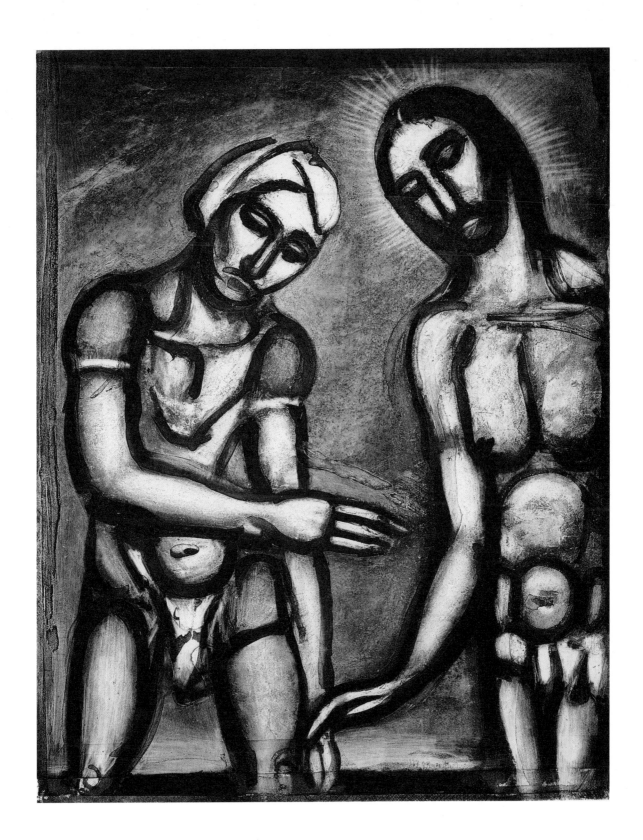

plate 33

**and Veronica, with her soft linen,
still walks the road . . .**

**et Véronique au tendre lin passé encore sur
le chemin . . .**

And as they led him away, they laid hold upon
one Simon, a Cyrenian, coming out of the country,
and on him they laid the cross, that he might bear
it after Jesus. And there followed him a great
company of people, and of women, which also
bewailed and lamented him. But Jesus turning unto
them said, Daughters of Jerusalem, weep not for
me, but weep for yourselves, and for your children.
Luke 23:26–28

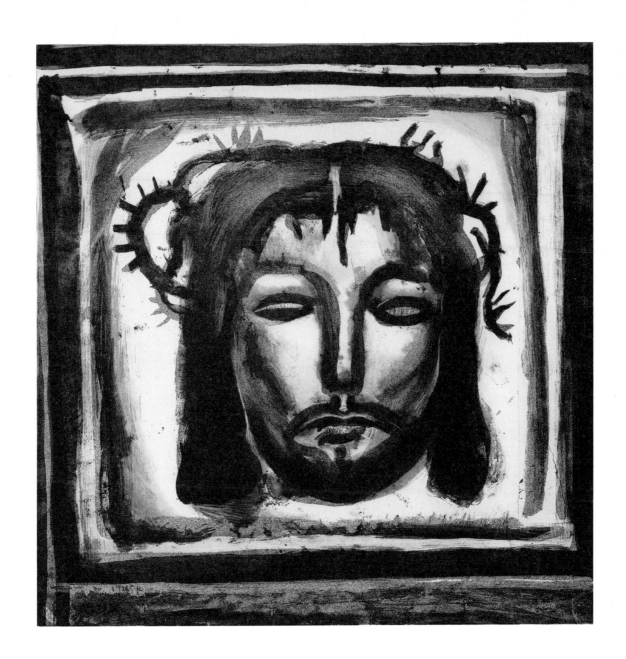

plate 34

"The very ruins have been destroyed."

"Les ruines elles-mêmes ont péri."

In that day will I raise up the tabernacle of David
that is fallen, and close up the breaches thereof;
and I will raise up his ruins, and I will build it as
in the days of old.

Amos 9:11

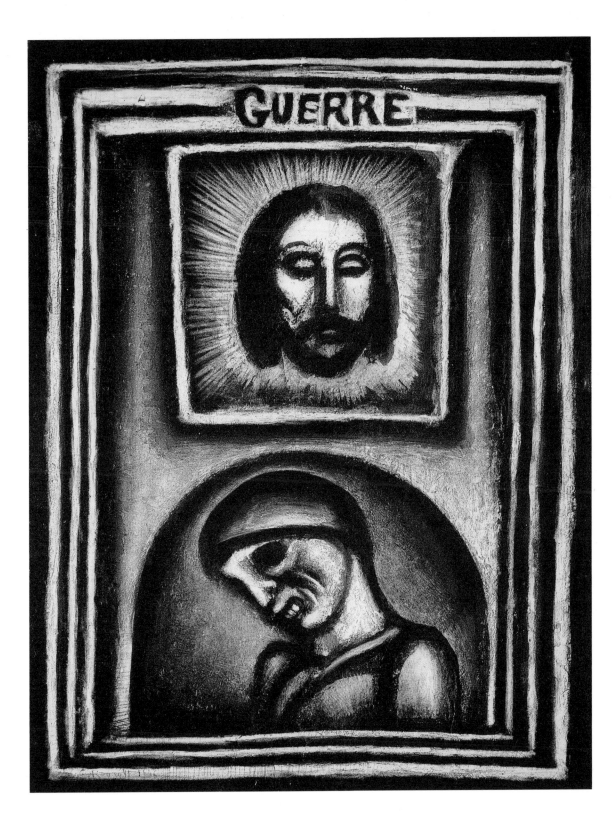

plate 35

"Jesus will be in agony until the end of the world ... "

"Jésus sera en agonie jusqu'à la fin du monde ..."

He is despised and rejected of men; a man of sorrows, and acquainted with grief: and we hid as it were our faces from him; he was despised, and we esteemed him not. Surely he hath borne our griefs, and carried our sorrows: yet we did esteem him stricken, smitten of God, and afflicted. But he was wounded for our transgressions, he was bruised for our iniquities: the chastisement of our peace was upon him; and with his stripes we are healed.

ISAIAH 53:3–5

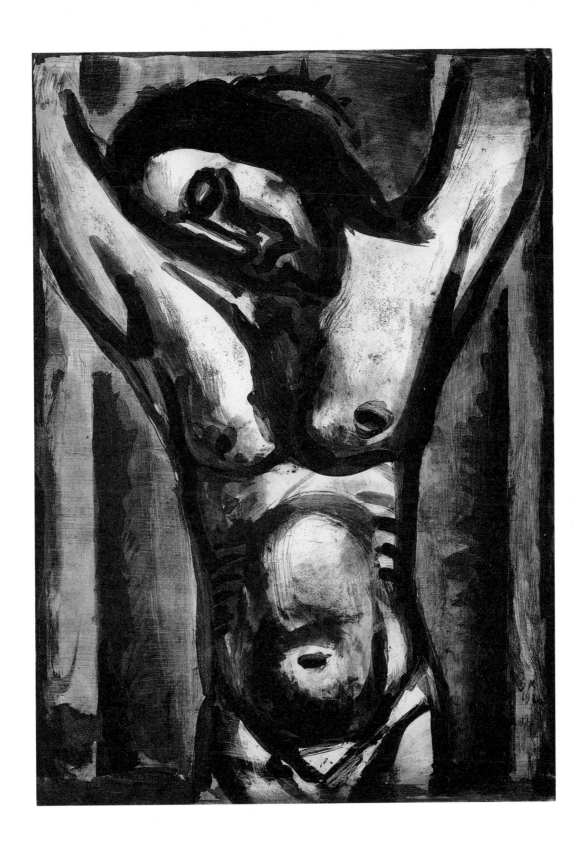

plate 36

This will be the last time, little father!

Ce sera la dernière, petit père!

My son, walk not thou in the way with them;
refrain thy foot from their path: For their feet
run to evil, and make haste to shed blood. Surely
in vain the net is spread in the sight of any bird.
And they lay wait for their own blood; they lurk
privily for their own lives.
Proverbs 1:15–18

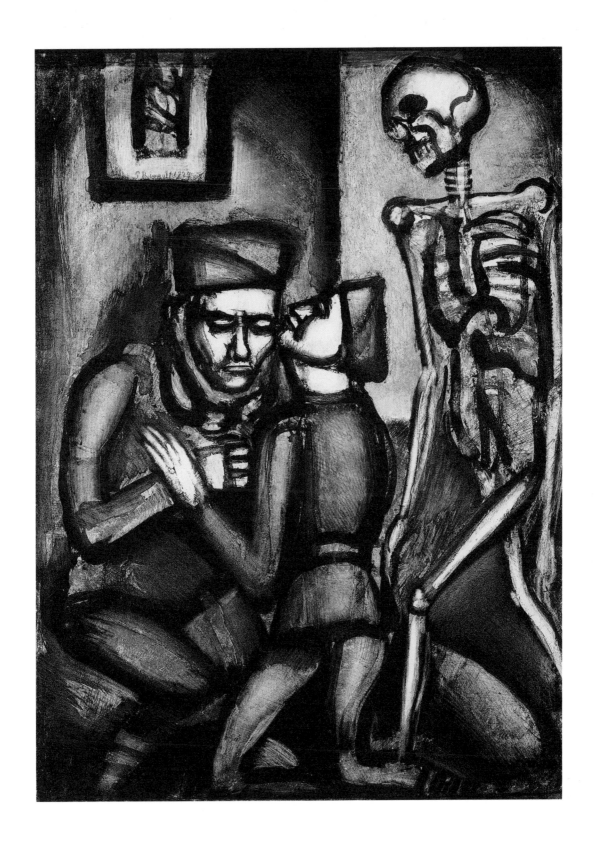

plate 37

Man is wolf to man.

Homo homini lupus.

And it shall come to pass, that before they call, I will answer; and while they are yet speaking, I will hear. The wolf and the lamb shall feed together, and the lion shall eat straw like the bullock: and dust shall be the serpent's meat. They shall not hurt nor destroy in all my holy mountain, saith the Lord.

Isaiah 65:24–25

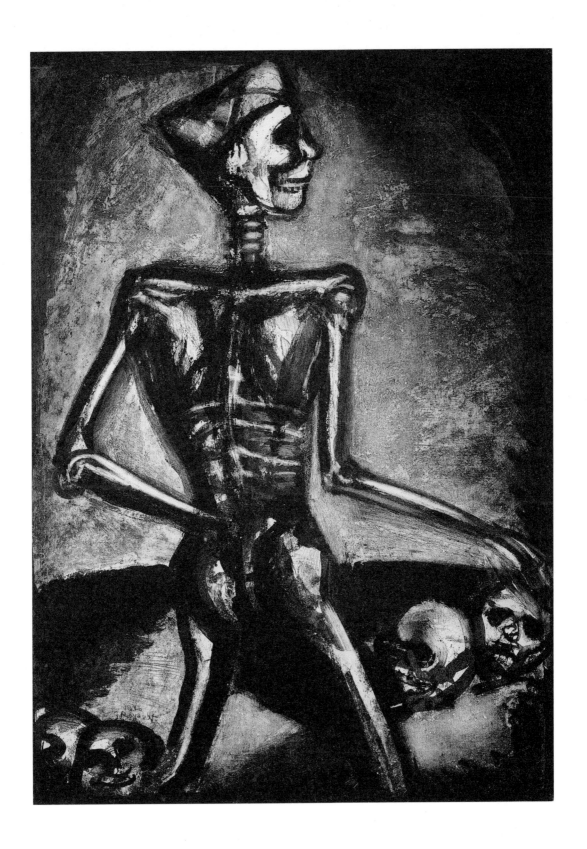

plate 38

The Chinese invented, they say, gunpowder, made us a gift of it.

Chinois inventa, dit-on, la poudre à canon, nous en fit don.

Wise men lay up knowledge: but the mouth of the foolish is near destruction.

PROVERBS 10:14

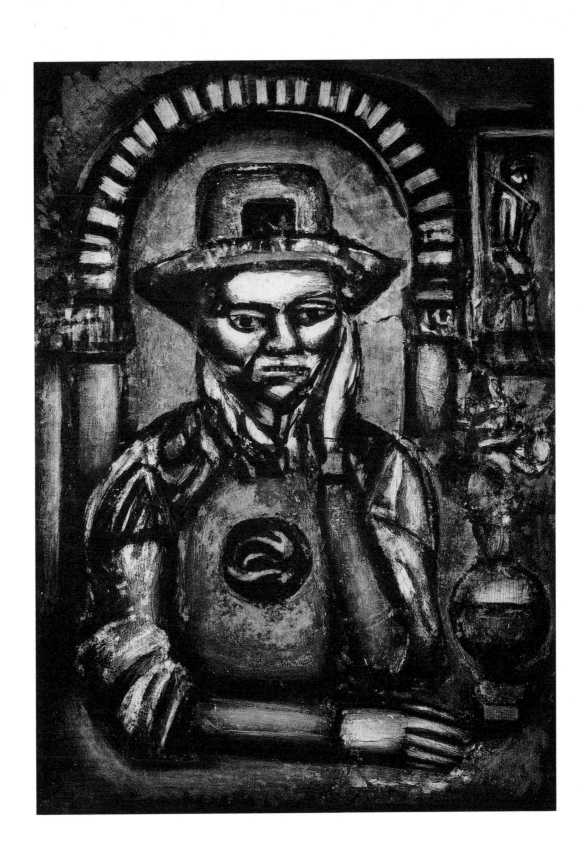

plate 39

We are insane.

Nous sommes fous.

This is an evil among all things that are done under the sun, that there is one event unto all: yea, also the heart of the sons of men is full of evil, and madness is in their heart while they live, and after that they go to the dead.

ECCLESIASTES 9:3

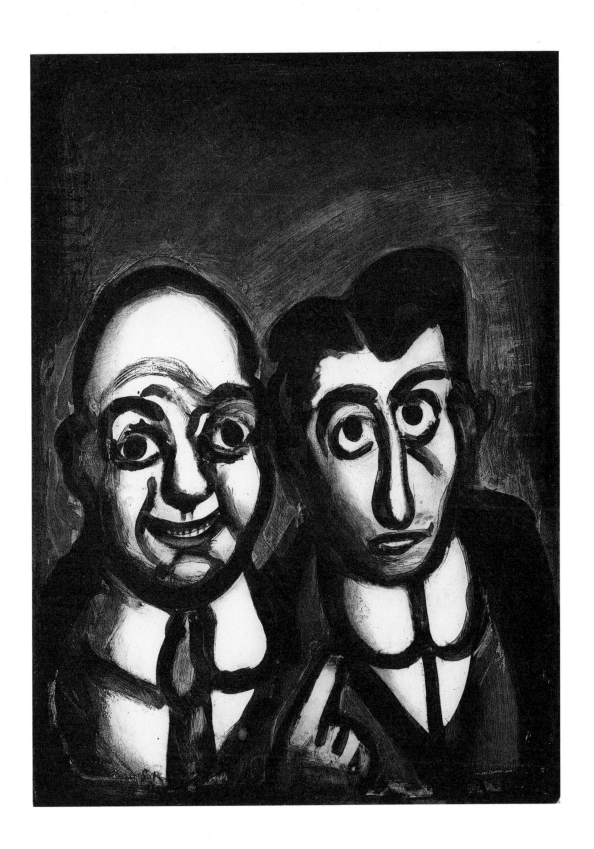

plate 40

Face to face.

Face à face.

Pilate saith unto them, What shall I do then with Jesus which is called Christ? They all say unto him, Let him be crucified. And the governor said, Why, what evil hath he done? But they cried out the more, saying, Let him be crucified. When Pilate saw that he could prevail nothing, but that rather a tumult was made, he took water, and washed his hands before the multitude, saying, I am innocent of the blood of this just person: see ye to it.

MATTHEW 27:22–24

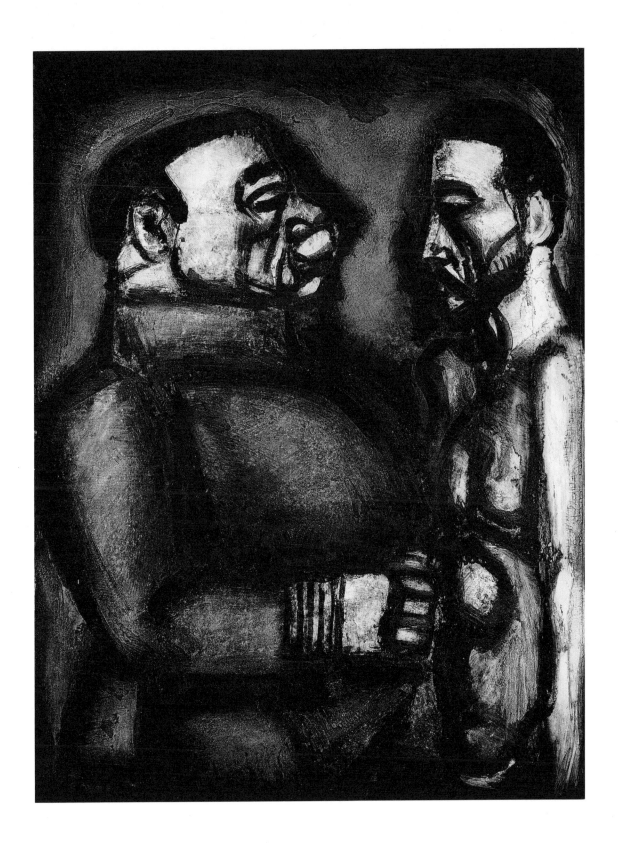

plate 41

Auguries.

Augures.

. . . the great temptations which thine eyes have seen, the signs, and those great miracles: yet the Lord hath not given you an heart to perceive, and eyes to see, and ears to hear, unto this day.

DEUTERONOMY 29:3–4

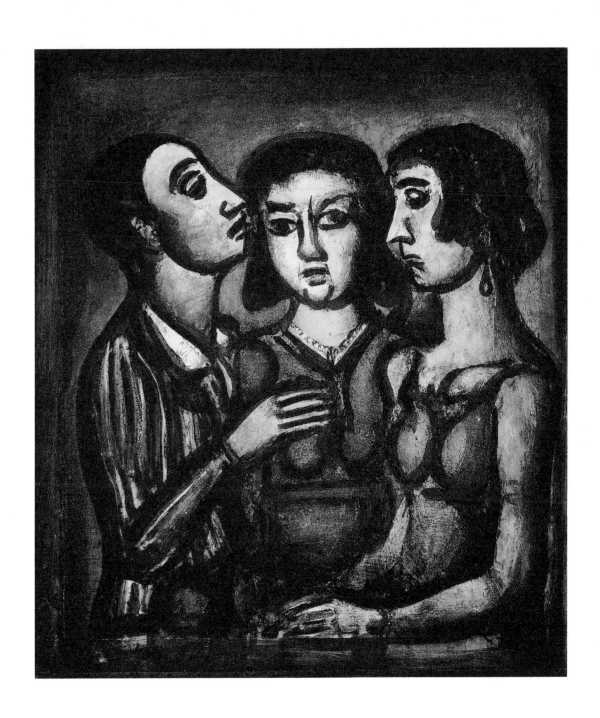

plate 42

War, so detested by mothers.

Bella matribus detestata.

Our inheritance is turned to strangers, our houses to aliens. We are orphans and fatherless, our mothers are as widows.

LAMENTATIONS 5:2–3

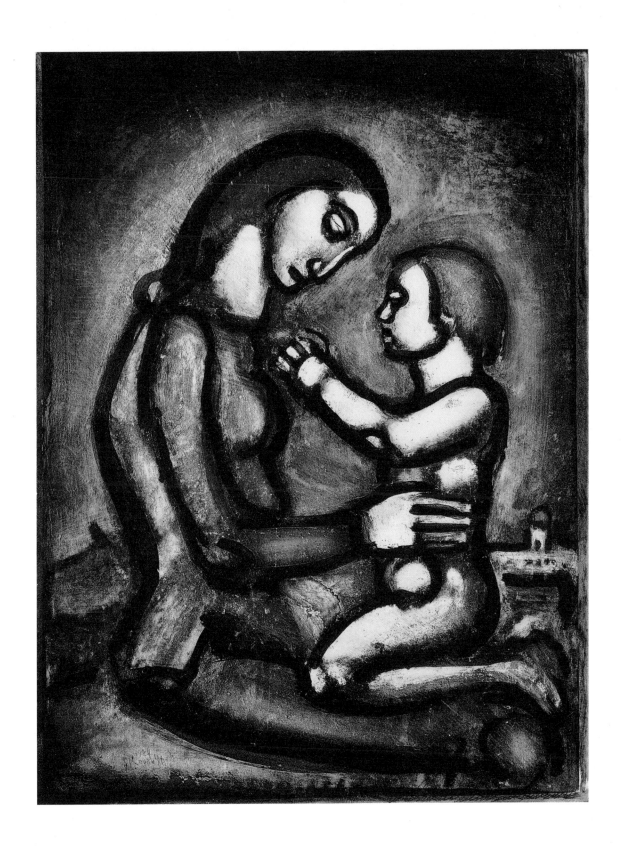

plate 43

"We must die, we and all that is ours."

"Nous devons mourir, nous et tout ce qui est nôtre."

And the Lord God commanded the man, saying, Of every tree of the garden thou mayest freely eat: but of the tree of the knowledge of good and evil, thou shalt not eat of it: for in the day that thou eatest thereof thou shalt surely die.

GENESIS 2:16–17

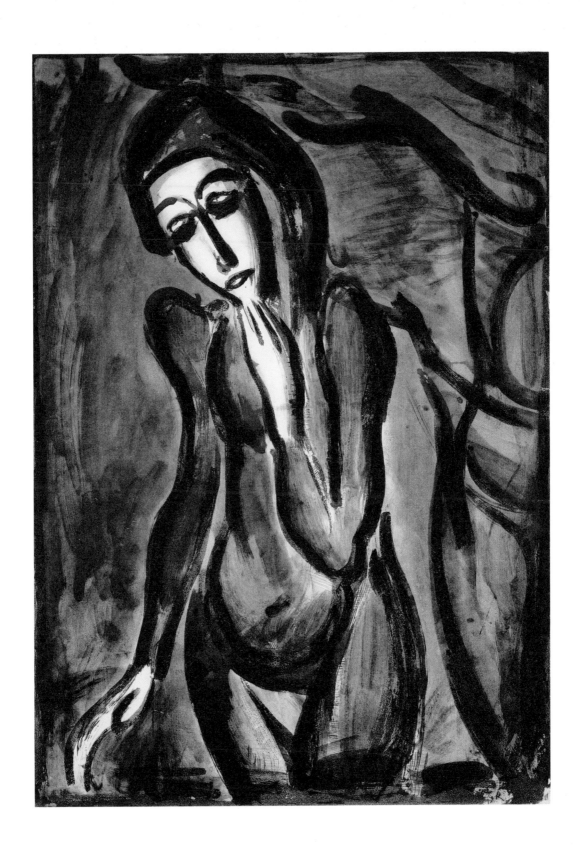

plate 44

My sweet country, where are you?

Mon doux pays, où êtes-vous?

My bowels, my bowels! I am pained at my very heart; my heart maketh a noise in me; I cannot hold my peace, because thou hast heard, O my soul, the sound of the trumpet, the alarm of war. Destruction upon destruction is cried; for the whole land is spoiled: suddenly are my tents spoiled, and my curtains in a moment. How long shall I see the standard, and hear the sound of the trumpet?

JEREMIAH 4:19–21

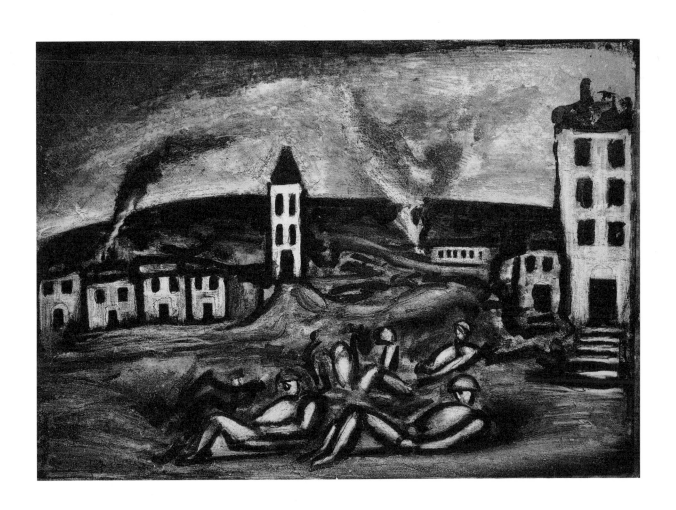

plate 45

Death took him as he arose from his bed of nettles.

La mort l'a pris comme il sortait du lit d'orties.

What will ye do in the solemn day, and in the day of the feast of the Lord? For, lo, they are gone because of destruction: Egypt shall gather them up, Memphis shall bury them: the pleasant places for their silver, nettles shall possess them: thorns shall be in their tabernacles.

HOSEA 9:5–6

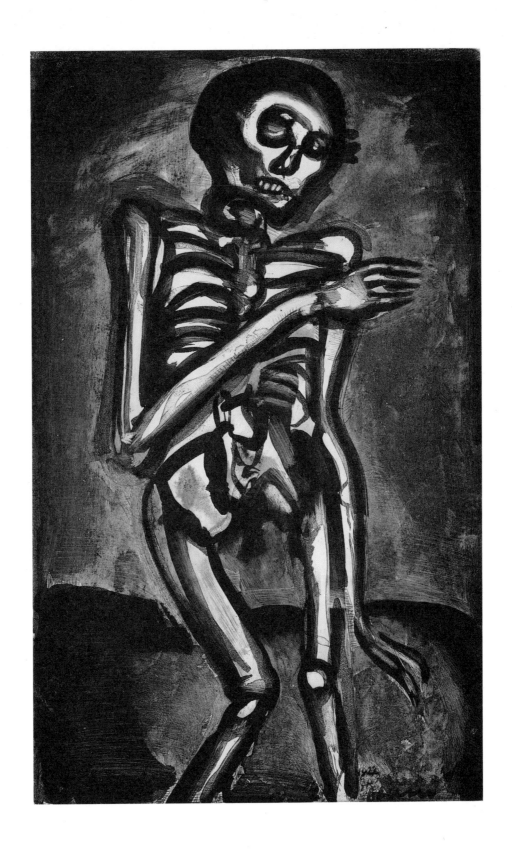

plate 46

"The just man, like sandalwood, perfumes the axe that strikes him."

"Le juste, comme le bois de santal, parfume la hache qui le frappe."

And, behold, a woman in the city, which was a sinner, when she knew that Jesus sat at meat in the Pharisee's house, brought an alabaster box of ointment, and stood at his feet behind him weeping, and began to wash his feet with tears, and did wipe them with the hairs of her head, and kissed his feet, and anointed them with the ointment.

LUKE 7:37–38

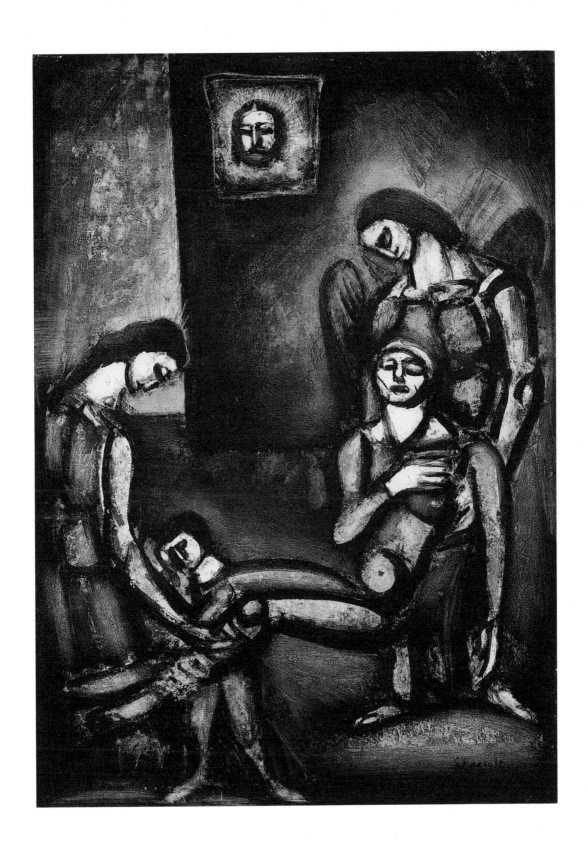

plate 47

"Out of the depths . . ."

"De profundis . . ."

Out of the depths have I cried unto thee, O Lord. Lord, hear my voice: let thine ears be attentive to the voice of my supplications. If thou, Lord, shouldest mark iniquities, O Lord, who shall stand? But there is forgiveness with thee, that thou mayest be feared.
Psalm 130:1–4

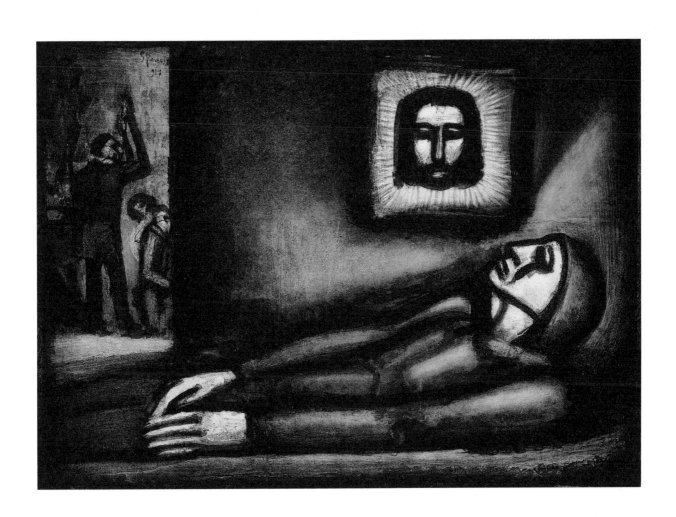

plate 48

In the winepress, the grapes were crushed.

Au pressoir, le raisin fut foulé.

For I say unto you, I will not drink of the fruit of the vine, until the kingdom of God shall come. And he took bread, and gave thanks, and brake it, and gave unto them, saying, This is my body which is given for you: this do in remembrance of me. Likewise also the cup after supper, saying, This cup is the new testament in my blood, which is shed for you.

Luke 22:18–20

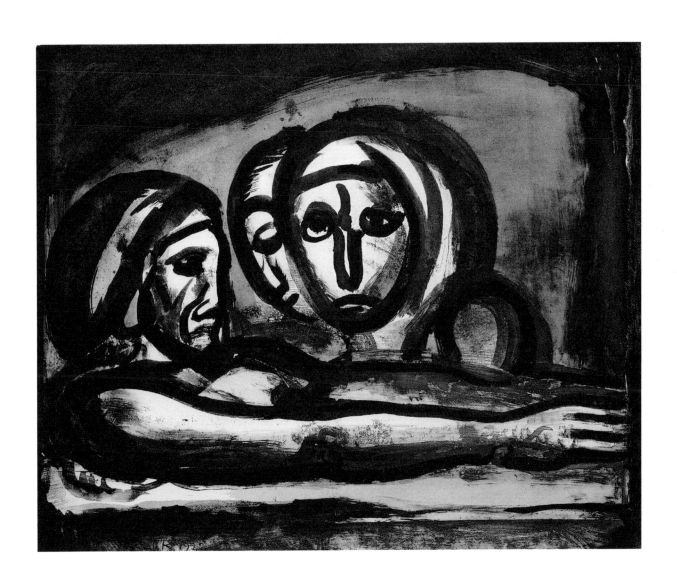

plate 49

"The nobler the heart, the less stiff the collar."

"Plus le coeur est noble, moins le col est roide."

Proud and haughty scorner is his name, who dealeth in proud wrath.

PROVERBS 21:24

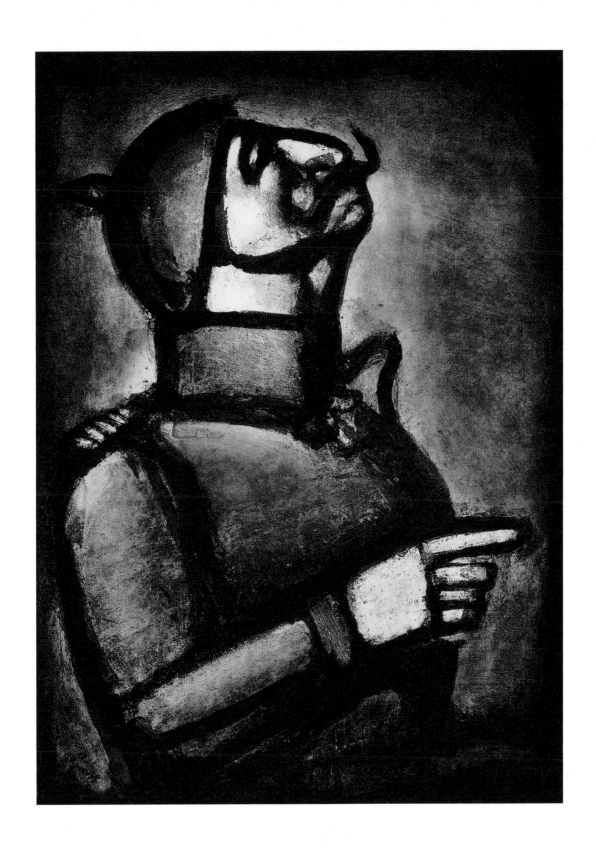

plate 50

"With tooth and nail."

"Des ongles et du bec."

Favour is deceitful, and beauty is vain: but a woman that feareth the Lord, she shall be praised.

PROVERBS 31:30

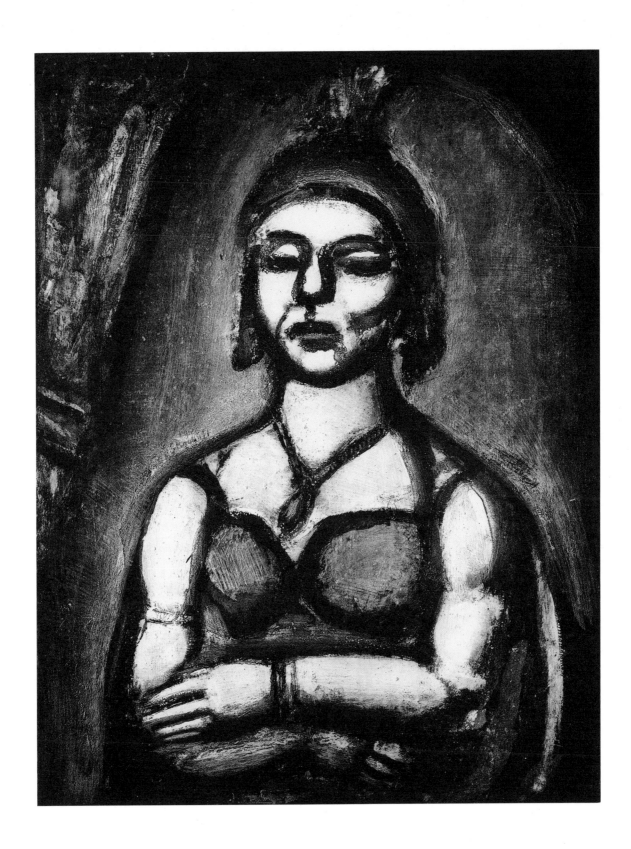

plate 51

Far from the smile of Reims.

Loin du sourire de Reims.

For I was envious at the foolish, when I saw the prosperity of the wicked. For there are no bands in their death: but their strength is firm. They are not in trouble as other men; neither are they plagued like other men. Therefore pride compasseth them about as a chain; violence covereth them as a garment. Their eyes stand out with fatness: they have more than heart could wish. They are corrupt, and speak wickedly concerning oppression: they speak loftily. They set their mouth against the heavens, and their tongue walketh through the earth. Therefore his people return hither: and waters of a full cup are wrung out to them.

PSALM 73:3–10

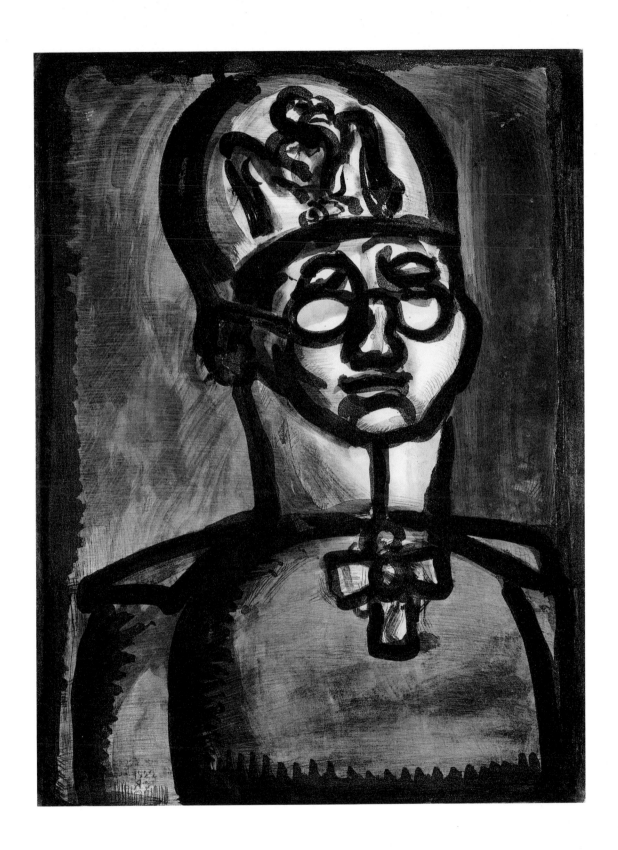

plate 52

The law is hard, but it is the law.

Dura lex sed lex.

The wicked in his pride doth persecute the poor: let them be taken in the devices that they have imagined. For the wicked boasteth of his heart's desire, and blesseth the covetous, whom the Lord abhorreth. The wicked, through the pride of his countenance, will not seek after God: God is not in all his thoughts.

Psalm 10:2–4

There is therefore now no condemnation to them which are in Christ Jesus, who walk not after the flesh, but after the Spirit. For the law of the Spirit of life in Christ Jesus hath made me free from the law of sin and death.

Romans 8:1–2

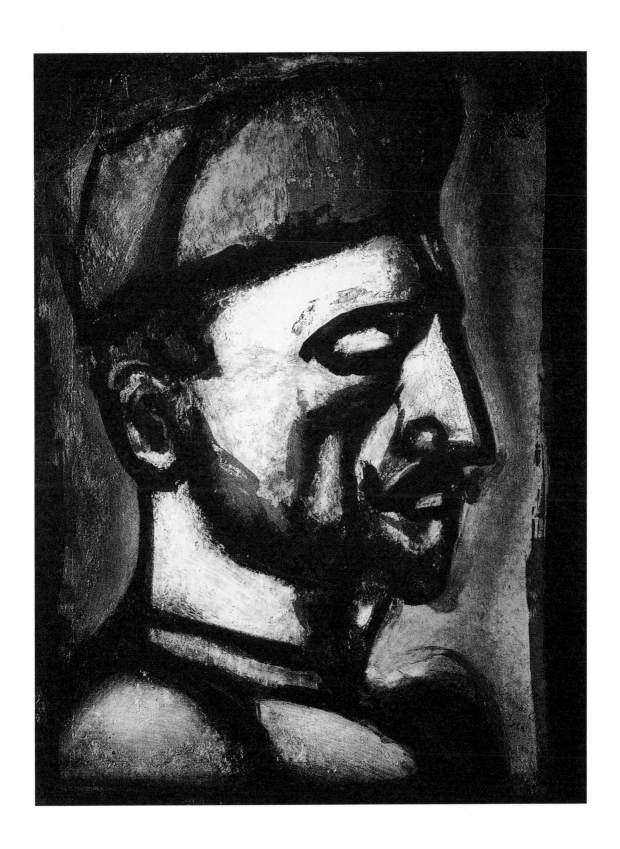

plate 53

The Virgin of the seven swords.

Vierge aux sept glaives.

Justice and judgment are the habitation of thy throne: mercy and truth shall go before thy face. Blessed is the people that know the joyful sound: they shall walk, O Lord, in the light of thy countenance. In thy name shall they rejoice all the day: and in thy righteousness shall they be exalted. For thou art the glory of their strength: and in thy favour our horn shall be exalted. For the Lord is our defence; and the Holy One of Israel is our king.

PSALM 89:14–18

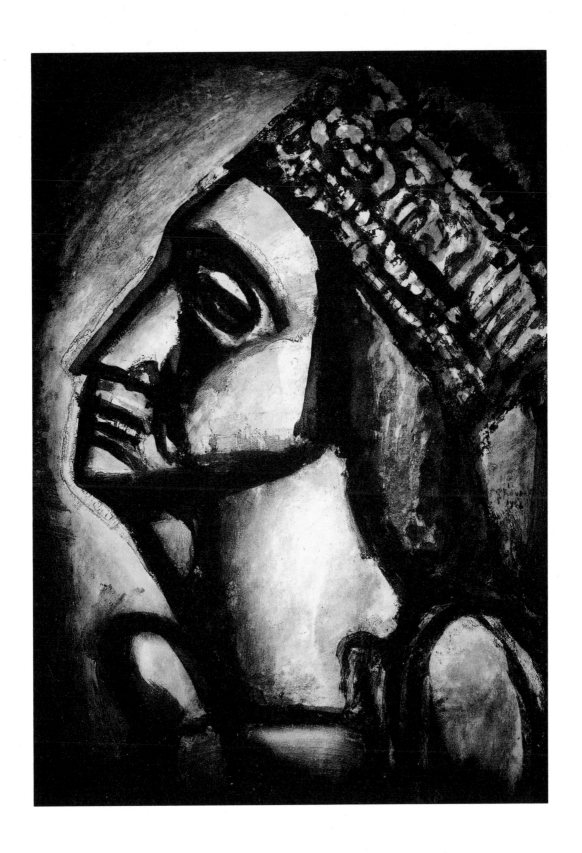

plate 54

"Arise, you dead!"

"Debout les Morts!"

The hand of the Lord was upon me, and carried me out in the spirit of the Lord, and set me down in the midst of the valley which was full of bones, and caused me to pass by them round about: and, behold, there were very many in the open valley; and, lo, they were very dry. And he said unto me, Son of man, can these bones live? And I answered, O Lord God, thou knowest.

EZEKIEL 37:1–3

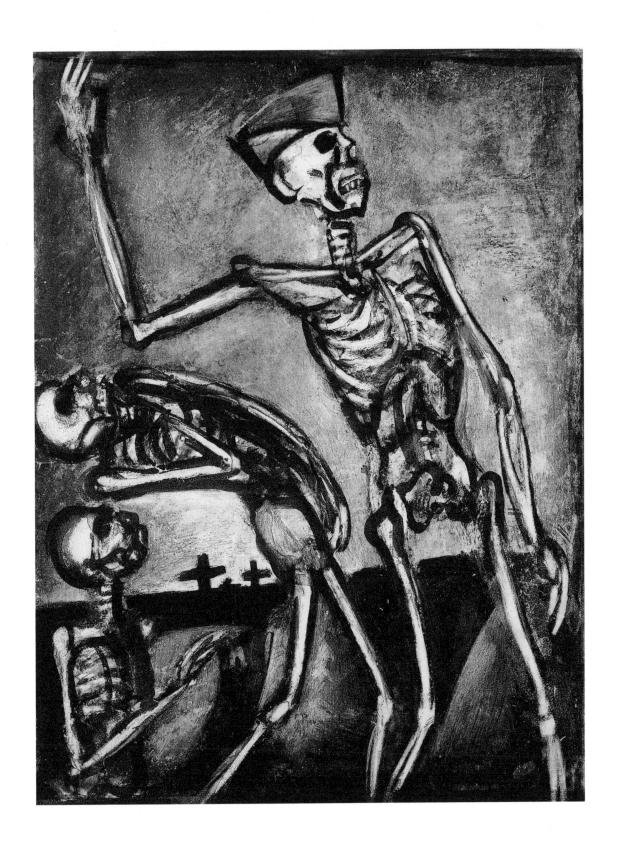

plate 55

Sometimes, the blind man consoles the seeing.

L'aveugle parfois a consolé le voyant.

And as they departed from Jericho, a great multitude followed him. And, behold, two blind men sitting by the way side, when they heard that Jesus passed by, cried out, saying, Have mercy on us, O Lord, thou son of David. And the multitude rebuked them, because they should hold their peace: but they cried the more, saying, Have mercy on us, O Lord, thou son of David. And Jesus stood still, and called them, and said, What will ye that I shall do unto you? They say unto him, Lord, that our eyes may be opened. So Jesus had compassion on them, and touched their eyes: and immediately their eyes received sight, and they followed him.

MATTHEW 20:29–34

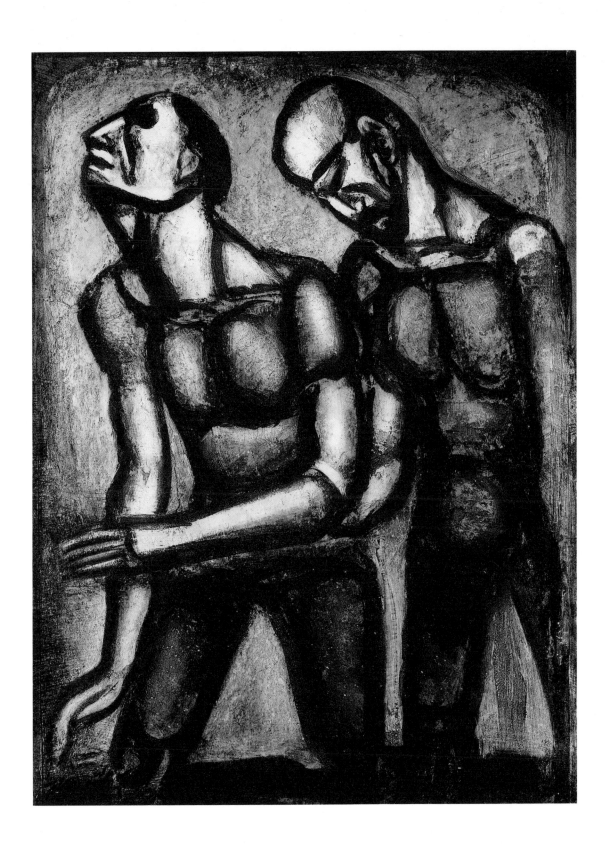

plate 56

In these dark times of vainglory and unbelief, vigilant is Our Lady of the End of the Earth.

En ces temps noirs de jactance et d'incroyance, Notre-Dame de la Fin des Terres vigilante.

And Mary said, My soul doth magnify the Lord, and my spirit hath rejoiced in God my Saviour. For he hath regarded the low estate of his handmaiden: for, behold, from henceforth all generations shall call me blessed. For he that is mighty hath done to me great things; and holy is his name. And his mercy is on them that fear him from generation to generation. He hath shewed strength with his arm; he hath scattered the proud in the imagination of their hearts. He hath put down the mighty from their seats, and exalted them of low degree. He hath filled the hungry with good things; and the rich he hath sent empty away.

LUKE 1:46–53

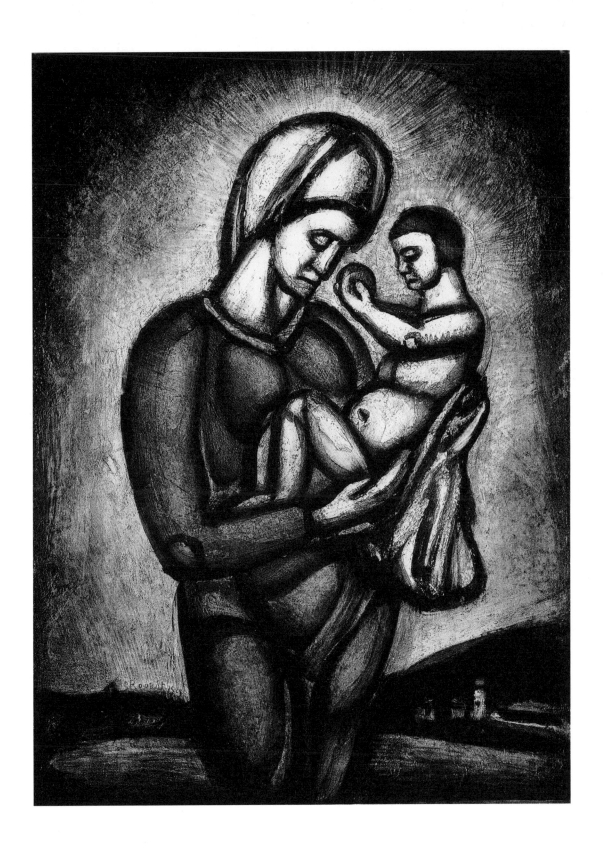

plate 57

"Obedient unto death, even the death of the Cross."

"Obéissant jusqu'à mort et à la mort de la croix."

But made himself of no reputation, and took upon him the form of a servant, and was made in the likeness of men: And being found in fashion as a man, he humbled himself, and became obedient unto death, even the death of the cross. Wherefore God also hath highly exalted him, and given him a name which is above every name.

PHILIPPIANS 2:7–9

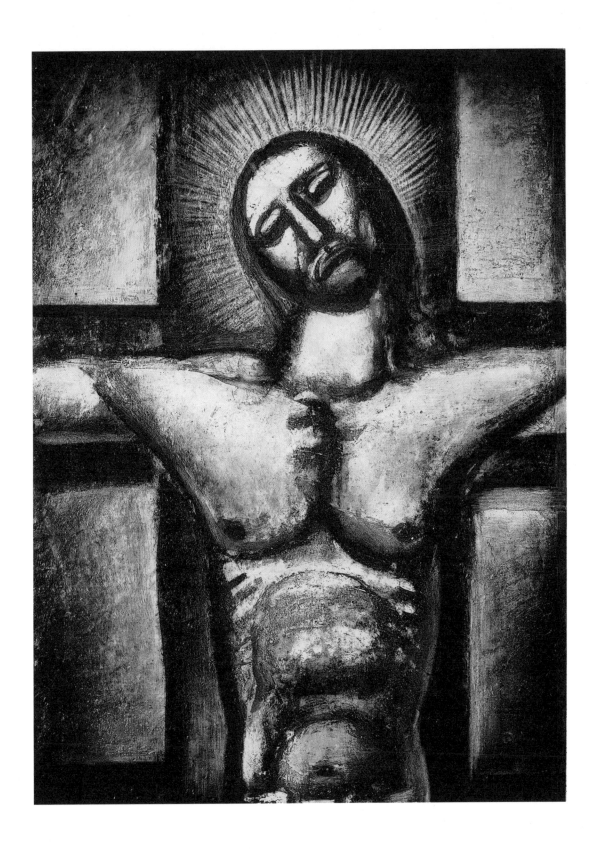

plate 58

**"It is through his wounds that we
are healed."**

**"C'est par ses meurtrissures que nous
sommes guéris."**

For even hereunto were ye called: because Christ also suffered for us, leaving us an example, that ye should follow his steps: who did no sin, neither was guile found in his mouth: who, when he was reviled, reviled not again; when he suffered, he threatened not; but committed himself to him that judgeth righteously: who his own self bare our sins in his own body on the tree, that we, being dead to sins, should live unto righteousness: by whose stripes ye were healed.

I PETER 2:21–24

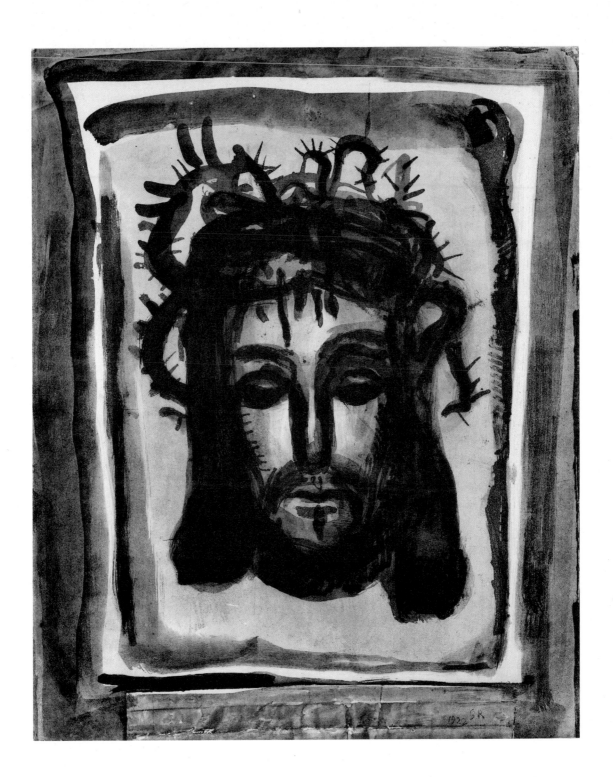

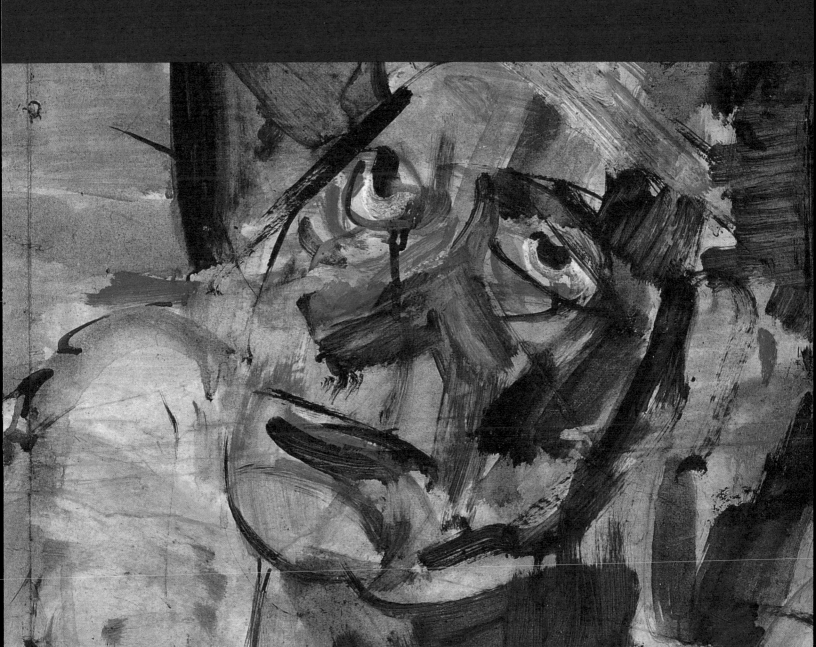

Head of Christ

Then when Mary was come where Jesus was, and saw him, she fell down at his feet, saying unto him, Lord, if thou hadst been here, my brother had not died. When Jesus therefore saw her weeping, and the Jews also weeping which came with her, he groaned in the spirit, and was troubled, And said, Where have ye laid him? They said unto him, Lord, come and see. Jesus wept. Then said the Jews, Behold how he loved him!

JOHN 11:32–36

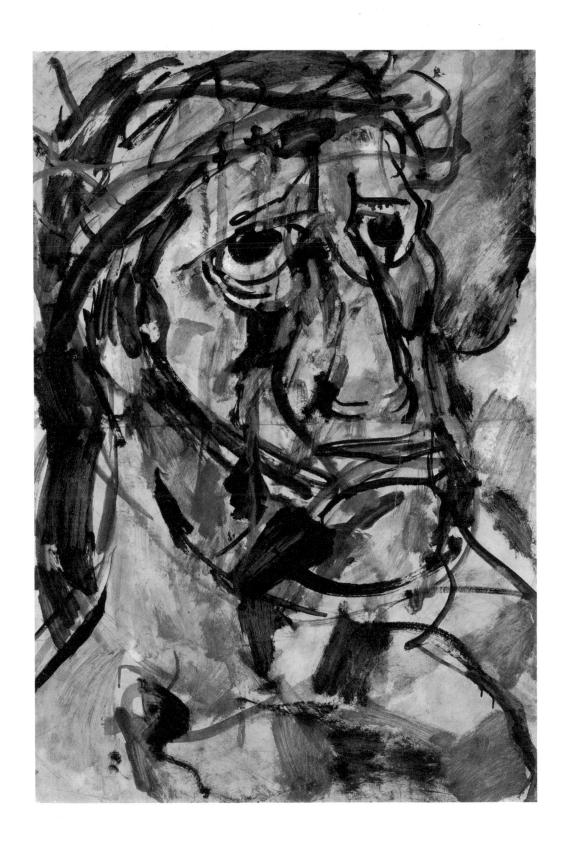

Clown

The Lord maketh poor, and maketh rich: he bringeth low, and lifteth up. He raiseth up the poor out of the dust, and lifteth up the beggar from the dunghill, to set them among princes, and to make them inherit the throne of glory: for the pillars of the earth are the Lord's, and he hath set the world upon them.

1 SAMUEL: 2:7–8

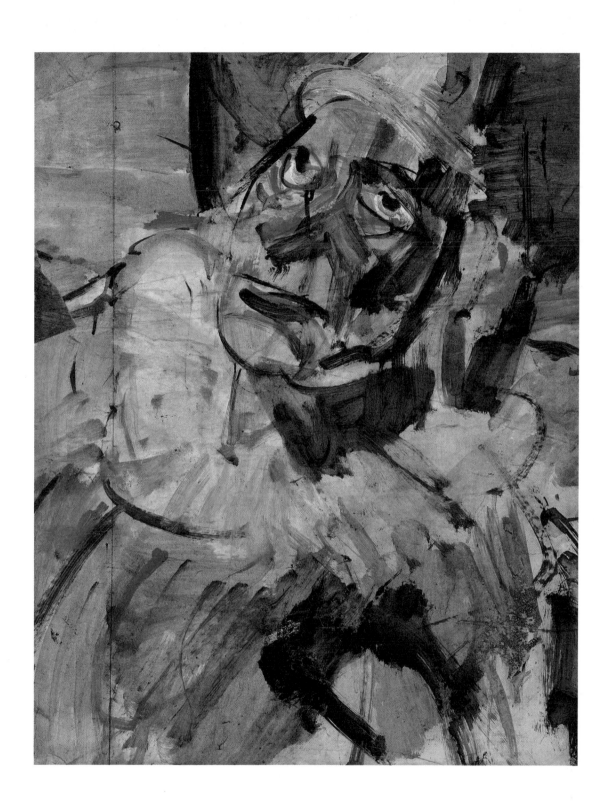

Resurrection

Now upon the first day of the week, very early in the morning, they came unto the sepulchre, bringing the spices which they had prepared, and certain others with them. And they found the stone rolled away from the sepulchre. And they entered in, and found not the body of the Lord Jesus. And it came to pass, as they were much perplexed thereabout, behold, two men stood by them in shining garments: and as they were afraid, and bowed down their faces to the earth, they said unto them, Why seek ye the living among the dead?

LUKE 24:1–5

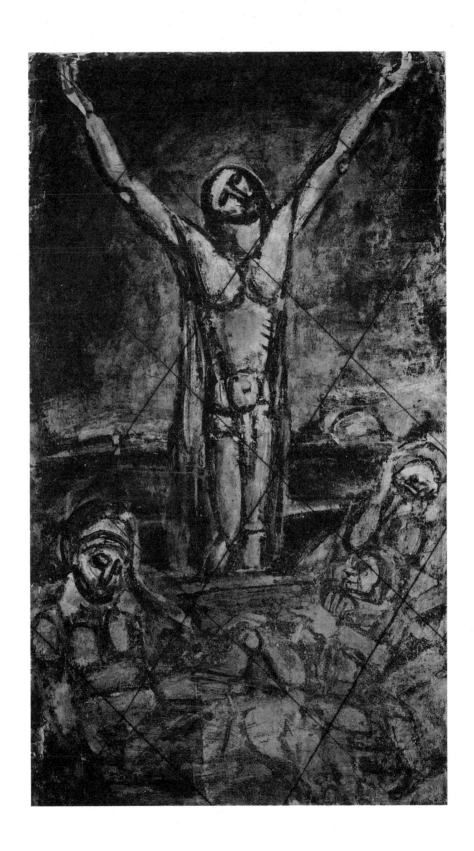

Head of a Clown

The wise man's eyes are in his head; but the fool walketh in darkness: and I myself perceived also that one event happeneth to them all. Then said I in my heart, As it happeneth to the fool, so it happeneth even to me; and why was I then more wise? Then I said in my heart, that this also is vanity. For there is no remembrance of the wise more than of the fool for ever; seeing that which now is in the days to come shall all be forgotten. And how dieth the wise man? as the fool. . . . And who knoweth whether he shall be a wise man or a fool?

ECCLESIASTES 2:14–16, 19

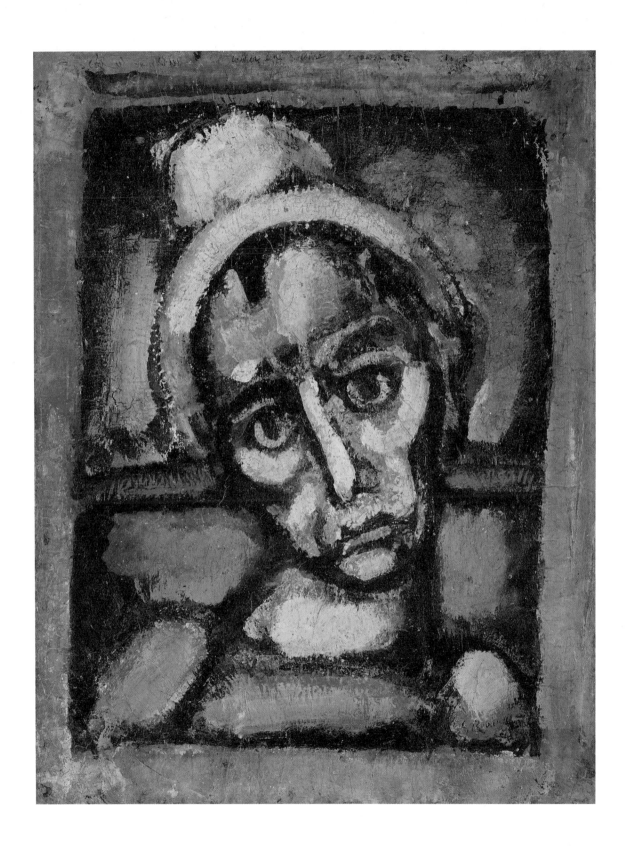

The Crucifixion

And Jesus cried with a loud voice, and gave up the ghost. And the veil of the temple was rent in twain from the top to the bottom. And when the centurion, which stood over against him, saw that he so cried out, and gave up the ghost, he said, Truly this man was the Son of God. There were also women looking on afar off: among whom was Mary Magdalene, and Mary the mother of James the less and of Joses, and Salome; (Who also, when he was in Galilee, followed him, and ministered unto him;) and many other women which came up with him unto Jerusalem.

MARK 15:37–41

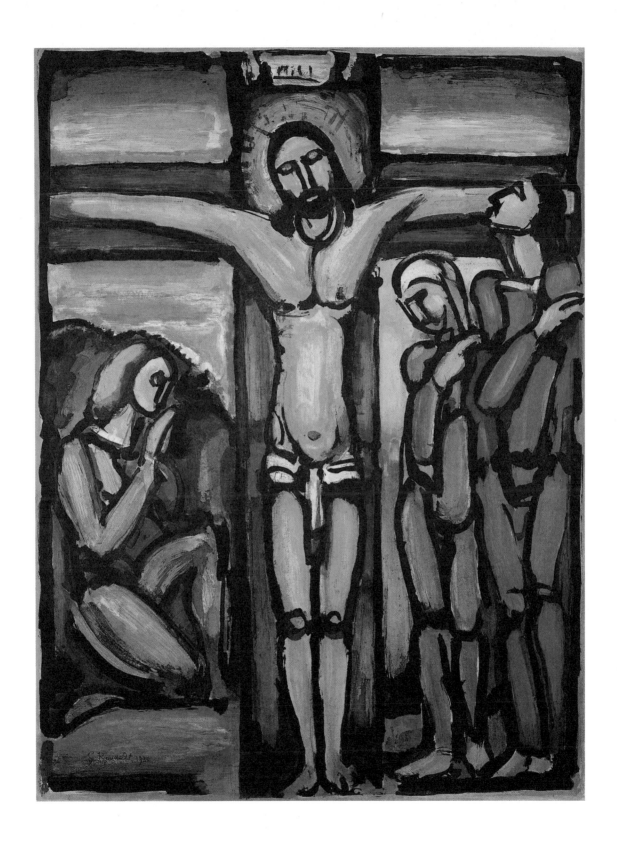

CHECKLIST OF THE EXHIBITION

PART I—MISERERE ET GUERRE

Miserere et Guerre
Designed 1912–18, 1922–27; published 1948
Aquatint, roulette, and drypoint over heliogravure
25 ⅝ x 19 ¾ inches
Collection of Robert and Sandra Bowden

Miserere

plate 1
Have mercy upon me, O God, according to thy loving-kindness.
Miserere mei, Deus, secundum magnam misericordiam tuam.

plate 2
Jesus despised . . .
Jésus honni . . .

plate 3
eternally flagellated . . .
toujours flagellé . . .

plate 4
take refuge in your heart, vagabond of misfortune.
se réfugie en ton coeur, va-nu-pieds de malheur.

plate 5
Lonely, in this life of pitfalls and malice.
Solitaire, en cette vie d'embûches et de malices.

plate 6
Are we not convicts?
Ne sommes-nous pas forçats?

plate 7
believing ourselves kings.
nous croyant rois.

plate 8
Who does not put on make-up?
Qui ne se grime pas?

plate 9
At times the road is beautiful . . .
Il arrive parfois que la route soit belle . . .

plate 10
in the old district of Long Suffering.
au vieux faubourg des Longues Peines.

plate 11
Tomorrow will be beautiful, said the shipwrecked man.
Demain sera beau, disait le naufragé.

plate 12
The hard work of living . . .
Le dur métier de vivre . . .

plate 13
it would be so sweet to love.
il serait si doux d'aimer.

plate 14
A young woman called joy.
Fille dite de joie.

plate 15
In a mouth which was once fresh, the taste of bitterness.
En bouche qui fut fraîche, goût de fiel.

plate 16
The upper class lady believes she holds a reserved seat in Heaven.
Dame du Haut-Quartier croit prendre pour le Ciel place réservee.

plate 17
An emancipated woman, at two o'clock, sings noon.
Femme affranchie, à quatorze heures, chante midi.

plate 18
The condemned man has gone away . . .
Le condamné s'en est allé . . .

plate 19

**his lawyer, in hollow phrases, proclaims his
complete unconsciousness . . .**
son avocat, en phrases creuses, clame sa totale
inconscience . . .

plate 20

under a Jesus on the cross forgotten there.
sous un Jésus en croix oublié là.

plate 21

**"He was oppressed, and he was afflicted,
yet he opened not his mouth."**
"Il a été maltraité et opprimé et il n'a pas ouvert
la bouche."

plate 22

**Of so many different domains, the noble work of
sowing in hostile land.**
En tant d'ordres divers, le beau métier
d'ensemencer une terre hostile.

plate 23

Street of the Lonely.
Rue des Solitaires.

plate 24

"Winter, leper of the earth."
"Hiver lèpre de la terre."

plate 25

Jean-François never sings alleluia . . .
Jean-François jamais ne chante alleluia . . .

plate 26

in the land of thirst and fear.
au pays de la soif et de la peur.

plate 27

Here are the tears of things . . .
Sunt lacrymae rerum . . .

plate 28

**"He that believeth in me, though he were dead, yet
shall he live."**
"Celui qui croit en moi, fût-il mort, vivra."

plate 29

Sing Matins, a new day is born.
Chantez Matines, le jour renaît.

plate 30

**"We . . . were baptized into Jesus Christ,
were baptized into his death."**
"Nous . . . c'est en sa mort que nous avons
été baptisés."

plate 31

"Love one another."
"Aimez-vous les uns les autres."

plate 32

Lord, it is you, I know you.
Seigneur, c'est vous, je vous reconnais.

plate 33

**and Veronica, with her soft linen,
still walks the road . . .**
et Véronique au tendre lin passé encore sur
le chemin . . .

Guerre

plate 34

"The very ruins have been destroyed."
"Les ruines elles-mêmes ont péri."

plate 35

**"Jesus will be in agony until the end of
the world . . ."**
"Jésus sera en agonie jusqu'à la fin du monde . . ."

plate 36

This will be the last time, little father!
Ce sera la dernière, petit père!

plate 37

Man is wolf to man.
Homo homini lupus.

plate 38

**The Chinese invented, they say, gunpowder, made
us a gift of it.**
Chinois inventa, dit-on, la poudre à canon, nous
en fit don.

plate 39

We are insane.
Nous sommes fous.

plate 40

Face to face.
Face à face.

plate 41

Auguries.
Augures.

plate 42

War, so detested by mothers.
Bella matribus detestata.

plate 43

"We must die, we and all that is ours."
"Nous devons mourir, nous et tout ce qui
est nôtre."

180

plate 44
My sweet country, where are you?
Mon doux pays, où êtes-vous?

plate 45
**Death took him as he arose from his bed
of nettles.**
La mort l'a pris comme il sortait du
lit d'orties.

plate 46
**"The just man, like sandalwood, perfumes
the axe that strikes him."**
"Le juste, comme le bois de santal, parfume
la hache qui le frappe."

plate 47
"Out of the depths . . ."
"De profundis . . ."

plate 48
In the winepress, the grapes were crushed.
Au pressoir, le raisin fut foulé.

plate 49
**"The nobler the heart, the less stiff
the collar."**
"Plus le coeur est noble, moins le col est roide."

plate 50
"With tooth and nail."
"Des ongles et du bec."

plate 51
Far from the smile of Reims.
Loin du sourire de Reims.

plate 52
The law is hard, but it is the law.
Dura lex sed lex.

plate 53
The Virgin of the seven swords.
Vierge aux sept glaives.

plate 54
"Arise, you dead!"
"Debout les Morts!"

plate 55
**Sometimes, the blind man consoles
the seeing.**
L'aveugle parfois a consolé le voyant.

plate 56
**In these dark times of vainglory and unbelief,
vigilant is Our Lady of the End of the Earth.**
En ces temps noirs de jactance et d'incroyance,
Notre-Dame de la Fin des Terres vigilante.

plate 57
**"Obedient unto death, even the death of
the Cross."**
"Obéissant jusqu'à mort et à la mort de la croix."

plate 58
**"It is through his wounds that we
are healed."**
"C'est par ses meurtrissures que nous
sommes guéris."

PART II—ADDITIONAL WORKS BY ROUAULT

Add. 1
Head of Christ
1906
Oil on paper and canvas
39 x 25 ¼ inches
Chrysler Museum of Art,
Gift of Walter P. Chrysler, Jr.

Add. 2
Clown
1907 or 1908
Watercolor and oil
23 ¾ x 18 ½ inches
Courtesy of Dumbarton Oaks, House Collection,
Washington, D.C.

Add. 3
Resurrection
Canceled plate for *Miserere et Guerre*,
1922–27
25 ¼ x 16 ½ inches
Collection of Robert and Sandra Bowden

Add. 4
Head of a Clown
After 1930
Oil and gouache on paper mounted on linen
25 ½ x 19 ½ inches
Indianapolis Museum of Art,
Gift in memory of William Ray Adams

Add. 5
The Crucifixion
1936
Aquatint, roulette, and drypoint over heliogravure
26 ⅙ x 20 ½ inches
Collection of Robert and Sandra Bowden

BIBLIOGRAPHY

ARTICLES, ESSAYS, & BOOKS ON GEORGES ROUAULT

Adam, George. "Assy, miracle d'art sacré moderne." *France Illustration* 268 (25 December 1950): 585–92.

———. "Georges Rouault." *Paris-Journal* (5 July 1914).

Arland, Marcel. "About Georges Rouault." *Formes* 16 (June 1931): 96–97.

Bell, Clive. "Georges Rouault." *Apollo* 58 (October 1953): 104–6.

Boime, Albert. "Georges Rouault and the Academic Curriculum." *Art Journal* 29, no. 1 (Fall 1969): 36–39.

Bouleau-Rabaud, Wanda. "Trois dessins inédits de Rouault á l'École des Beaux-Arts." *Gazette des Beaux-Arts* 70, ser. 6 (November 1967): 299–302.

Bransten, Ellen. "Significance of the Clown in Paintings by Daumier, Picasso, and Rouault." *Pacific Arts Review* 3 (1944): 21–39.

Brion, Marcel. *Georges Rouault*. Paris: Braun; agent pour U.S.A.: E.S. Herrmann, 1950.

Carluccio, Luigi. *Georges Rouault*. Milan: Fabri, 1967.

Chabot, Georges. "Georges Rouault." *Cahiers d'Art* no. 3 (1928): 104–6.

———. "Georges Rouault." *La Revue d'Art* [Anvers] 29 (July–December 1928): 101–16.

———. "Rouault." *Les beaux-arts* [Brussels] (7 November 1952).

Chapon, François. *Le livre des livres de Rouault*. Monte-Carlo: Ed. A. Sauret; Paris: Ed. M. Trinckvel, 1992.

——— and Isabelle Rouault. *Rouault: oeuvre gravé*. 2 vols. Monte-Carlo: A. Sauret, 1978. Catalog raisonné.

Charensol, Georges. "Georges Rouault." *La Revue des Deux Mondes* 5 (1 March 1958): 148–53.

———. *Georges Rouault, le homme et l'oeuvre*. Paris: Éditions des quatre chemins, 1926.

Cocognoc, A. M. "Rouault." *L'Art Sacré* 5–6 (January–February 1964): 3–31.

Cogniat, Raymond. *Georges Rouault*. Paris: Éditions G. Crés et Cie, 1930.

———. "Georges Rouault." *Les Arts Plastiques* 4 (1952): 252–58.

Coquiot, Gustave. "Rouault." In his *Des peintres maudits*. Paris: A. Delpeuch, 1924: 115–23.

———. "Rouault, poéte de l'horreur." In his *Vagabondages: à travers la peinture et les paysages, les bêtes et les hommes*. Paris: P. Ollendorff, 1921: 114–19.

Courthion, Pierre. "Georges Rouault." *Arts* (19–25 February 1958): 1, 18.

———. *Georges Rouault*. New York: H. N. Abrams, 1977.

———. *Georges Rouault. Including a Catalogue of Works Prepared with the Collaboration of Isabelle Rouault*. New York: H. N. Abrams, 1962.

———. *Georges Rouault; suivi d'un catalogue établi avec la collaboration d'Isabelle Rouault.* Paris: Flammarion, 1962.

———. *Rouault.* Paris: Nouvelle éditions françaises, 1971.

Courtney, J. "Head of a Clown." *John Heron Institute Bulletin* 36 (April 1949): 3–4.

Courturier, M. A. "Rouault." *L'Art Sacré* (September 1938).

Coutot, Maurice. "A propos du procés Rouault." *Arts* (December 1946): 1, 3.

———. "Rouault et son acheteur." *Arts de France* Nos. 15–16 (1947): 35–38.

Crispolti, Enrico. *Georges Rouault.* Milan: Fabri, 1965.

Davidson, Martha. "Rouault as Master of Graphic Art." *Art News* 37, no. 2 (8 October 1938): 10, 20.

———. "Rouault: Stained Glass in Paint: A New View of a Unique Modern Medievalist." *Art News* 36, no. 8 (20 November 1937): 8, 18.

Descargues, Pierre. "L'affaire Rouault-Vollard." *Arts* (March 1947): 1, 3.

Dorival, Bernard. "Autoportraits et portraits de Rouault." *Revue des Arts* 3 (December 1953): 229–38.

———. *Cinq études sur Georges Rouault.* Paris: Éditions universitaires, 1956.

———. "Georges Rouault." *La Table Ronde* 58 (1952): 175–80.

———. *Georges Rouault.* Geneva: R. Kister, 1956.

———. "Nouvelles oeuvres de Rouault au Musée d'art moderne." *Musées de France* 9 (November 1950): 193–200.

———. *Rouault.* Paris: Flammarion, 1982.

———. *Rouault.* New York: Crown Publishers, 1984.

——— and Isabelle Rouault. *Rouault, l'oeuvre peint.* 2 vols. Monte-Carlo: André Sauret, 1988. Catalog raisonné.

Dormoy, Marie. "Le cirque de l'Étoile filante." *Arts et Métiers Graphiques* 68 (15 May 1948): 35–40.

———. "Georges Rouault." *Kunst und Künstler* 29 (April 1931): 280–86.

Douaire, Richard. "Georges Rouault: His Art." *Liturgical Arts* 16 (May 1948): 72, 77–78.

Dyrness, William A. *Rouault: A Vision of Suffering and Salvation.* Grand Rapids, Mich.: Eerdmans, 1971.

Einstein, Carl. "Georges Rouault." *Der Querschnitt* 5 (March 1925): 244–48.

Eisendrath, W. "The Chinese by Georges Rouault." *St. Louis Museum Bulletin* 44, no. 1 (1960): 9–10.

Faerna, José María, ed. *Rouault.* New York: Cameo/Abrams, 1997.

Fierens, Paul. "Georges Rouault." *L'amour de l'art* (June 1933).

Finne, F., ed. *Kunsten Idag* 2, no. 28 (1954). Special issue on Rouault.

Francis, Henry. "A Head of Christ by Rouault." *Cleveland Museum Bulletin* 38, no. 4 (April 1951): 71–72.

Galeazzi, Giancarlo, ed. *Rouault.* Ancône: Bagaloni, 1977.

Goodall, Donald. "Rouault's Passion Cycle." *Art in America* 50, no. 4 (Winter 1962): 74–79.

Hergott, Fabrice. *Rouault.* Paris: Michel, 1991.

Herman, Josef. "In Homage to Rouault." *Studio* 172 (November 1966): 258–59.

Hommage à Georges Rouault. Paris: Société internationale d'art "XXe siècle," 1971.

Humbert, Agnés. "Georges Rouault." *Scottish Art Review* 6, no. 4 (13 February 1958): 2–6.

Ito, Ren. *Rouault*. Tokyo: Atelier-Sha, 1932.

Jacquinot, Jean. "Trois amis: Georges Rouault, Joris-Karl Huysmans et Léon Bloy." *Bulletin de la Société Huysmans* 34 (1937): 168–81.

Jewell, Edward Alden. *Georges Rouault*. Introduction by the artist. Paris; New York: Hyperion, 1947.

Johnson, Una. "Georges Rouault and His Prints." *Brooklyn Museum Bulletin* 13, no. 1 (1951): 6–12.

Kahn, Gustave. "Art." *Mercure de France* (16 January 1912).

———. "Salon d'Automne." *Le Radical* (30 September 1908): 1–2.

Kang, Soo Yun. *Rouault in Perspective: Contextual and Theoretical Study of His Art*. Lanham, Md.: International Scholars Publications, 2000.

———. "A Spiritual Interpretation of the Vernacular: The Literary Sources of Georges Rouault." *Logos* 6:2 (Spring 2003): 108–24.

Kind, Joshua. *Rouault*. New York: Tudor Pub. Co., 1969.

Lassaigne, Jacques. *Rouault*. Geneva; New York: Skira, 1951.

Léon-Martin, Louis. "George Rouault." *Art et décoration* 57 (April 1930): 111–14.

Lewisohn, Sam. "Rouault, Master of Dissonance." *Parnassus* 5 (November 1933): 1–7.

Lhote, André. "Rouault." *L'Amour de l'art* 4, no. 12 (December 1923): 779–82.

———. "Sur les compositions religieuses de Rouault." *Der Cicerone* (1 February 1924).

Lieberman, William. "Notes on Rouault as Printmaker." *Magazine of Art* 46, no. 4 (April 1953): 170–76.

Malraux, André. "Notes on Tragic Expression in Painting Apropos of the Recent Work of Rouault." *Formes* 1 (December 1929): 5–6.

Marchiori, Giuseppe. *Georges Rouault*. Milan: Silvana editoriale d'arte, 1965.

———. *Rouault*. New York: Reynal, In association with W. Morrow, 1967.

Maritain, Jacques. "Georges Rouault." *La Revue Universelle* 17, no. 4 (15 May 1924): 505–8.

———. *Georges Rouault*. Notes on Rouault's prints by William S. Lieberman. New York: H. N. Abrams in association with Pocket Books, 1954.

———. *Georges Rouault*. New York: H. N. Abrams, 1969.

Mellquist, Jerome. "Georges Rouault." *Commonweal* 29, no. 9 (23 December 1938): 232–34.

———. "Rouault, Prophet of Disaster." *Commonweal* 36 no. 17 (14 August 1942): 390–92.

Mitchell, Timothy. *The Passion: 99 Illustrations by Georges Rouault, Including 17 in Full Color*. Bloomington: Lilly Library of Indiana University in association with Dover Publications, New York, 1982.

Moutard-Uldry, Renée. "Monks of Ligugé: Medieval Enameling Techniques Restored for Contemporary Uses." *Craft Horizons* 12, no. 5 (September–October 1953): 26–29.

Musée d'art moderne de la ville de Paris. *Georges Rouault, 1871–1958: catalog raisonné*. Catalogue by Danielle Molinari with the assistance of Marie-Claire Anthonioz. Paris: Le Musée, 1983.

Neve, Christopher. "Rouault's Outrageous Lyricism." *Country Life* 155 (20 June 1974): 26–29.

Nouaille-Rouault, Geneviève. *Georges Rouault, mon père*. Paris: Léopard d'Or; Fondation Georges Rouault, 1998.

O'Connor, John. "Homage to the Old King." *Carnegie Magazine* 32 (April 1958): 129–31, 138.

———. "The Old King." *Carnegie Magazine* 14 (September 1940): 99–103.

———. "The Old King by Rouault." *Carnegie Magazine* 23 (December 1949): 167–68.

Pach, Walter. "Georges Rouault." *Parnassus* 5 (January 1933): 9–11.

Pichard, Joseph, ed. *L'art d'Église* (1953). Special Rouault issue.

Le Point 26–27 (August–October 1943). Special Rouault issue.

Puy, Michel. *Georges Rouault: Trente reproductions de peintures et dessins*. Paris: Editions de "la Nouvelle Revue française," 1920.

Rothenstein, J. "Visit to Rouault." *Museum Journal* 54 (March 1955): 315–16.

Rouault, Georges and André Suarès. *Correspondance [de] Georges Rouault [et] André Suarès*. Paris: Gallimard, 1960.

Rouault, Georges and André Suarès. *Georges Rouault–André Suarès Correspondence, 1911–1939*. Translated and edited from the French by Alice B. Low-Beer; introduction by Marcel Arland. Ilfracombe, Devon: A. H. Stockwell, 1983.

Roulet, Claude. *Rouault, souvenirs*. Neuchâtel: Messeiller, 1961.

Salmon, André. "Georges Rouault." *Paris-Journal* (12 December 1922).

San Lazzaro, G., ed. *XXe Siècle* (1971). Special issue: "Hommage à Georges Rouault."

Smith, Elaine. "Matisse and Rouault Illustrate Baudelaire." *Baltimore Museum News* 19 (October 1955): 1–9.

Sosset, L. L., ed. *Les Beaux-Arts* [Brussels] (21 March 1952). Special Rouault issue.

Stillson, B. "Vollard as a Clown." *John Heron Institute Bulletin* 35 (April 1948): 12–13.

Sutfin, Edward. "Georges Rouault." *Liturgical Arts* 31, no. 4 (August 1963): 119–21.

Vauxcelles, Louis. "Rouault." *Le Carnet des Artistes* (15 June 1917): 9–14.

———. "Rouault et Vollard." *L'Ére Nouvelle* (24 April 1924).

Venturi, Lionello. "Georges Rouault." *Parnassus* 11 (October 1939): 4–13.

———. *Georges Rouault*. New York: E. Weyhe, 1940.

———. *Georges Rouault*. 2nd edition. Paris: A. Skira, 1948.

———. "Georges Rouault." *Bollettino* [La Biennale di Venezia] no. 32 (1958).

———. *Rouault, Biographical and Critical Study*. New York: Skira, 1959.

Waldemar George. "Georges Rouault." *Bulletin de la vie artistique* (15 May 1924): 229–30.

———. "Georges Rouault." *Résistance* (2 August 1946).

———. "Georges Rouault and the Birth of Tragedy." *Formes* 13 (March 1931): 40–41.

———. "Georges Rouault. Ein romantischer französischer Maler." *Das Kunstblatt* 8 (August 1925): 225–29.

———, ed. "Georges Rouault. Oeuvres inédites." *La Renaissance* 20 (October–November 1937). Special Rouault number.

——— and Geneviève Nouaille-Rouault. *L'univers de Rouault*. Paris: H. Scrépel, 1971.

Wilenski, R. "Georges Rouault." *Apollo* 11, no. 62 (June 1930): 473–74.

Wind, Edgar. "Traditional Religion and Modern Art." *Art News* 52 (May 1953): 18–22, 60–63.

Wofsy, Alan. *Georges Rouault: The Graphic Work.* San Francisco: Alan Wofsy Fine Arts, 1976.

Zahar, M. "Georges Rouault; or, The Return to the Dramatic Grotesque — Illustrations for Vollard's *Les réincarnations du Père Ubu.*" *Formes* 31 (1933): 354–55.

Zervos, Christian. "Dernières oeuvres de Rouault." *Cahiers d'art* 33–35 (1960): 175–86.

———— "Illustrations de Georges Rouault pour *Les réincarnations du Père Ubu* de A. Vollard." *Cahiers d'art* 7, no. 1–2 (1932): 66–68.

Exhibition Catalogs & Brochures

Museum of Modern Art, New York. *The Prints of Georges Rouault.* Preface by Monroe Wheeler. New York: The Museum, 1938.

Buchholz Gallery, New York. *Georges Rouault, Lithographs & Etchings: May 6th–May 25th.* New York: The Gallery, 1940.

Institute of Modern Art, Boston. *Georges Rouault: Retrospective Loan Exhibition. Boston, the Institute of Modern Art; Washington, the Phillips Memorial Gallery; San Francisco, the San Francisco Museum of Art, November 1940, March 1941.* Introduction by Lionello Venturi. Boston: The Institute, 1940.

Museum of Modern Art, New York. *Georges Rouault: Paintings and Prints.* Contributions by James Thrall Soby, et al. New York: The Museum, 1945.

Galerie des garets, Paris. *Georges Rouault, oeuvres recentes.* Paris: Le galerie, 1947.

Pierre Matisse Gallery, New York. *Georges Rouault: Paintings, March 11th–April 5th, 1947.* New York: The Gallery, 1947.

Kunsthaus Zürich. *Georges Rouault: Ausstellung April–Juni 1948.* Preface by Maurice Morel; catalog by René Wehrli; afterword with bibliography by Wilhelm Wartmann. Zürich: s.n., 1948.

Perls Galleries, New York. *Georges Rouault, Paintings: October 31st to November 26th, 1949.* New York: The Galleries, 1949.

Musée national d'art moderne, Paris. *Georges Rouault, 9 juillet–26 octobre.* Paris: Éditions des musées nationaux, 1952.

Stedelijk Museum, Amsterdam. *Georges Rouault: Stedelijk Museum, Amsterdam.* Text by Georges Salles and Lionello Venturi. Brussels: Editions de la connaissance, 1952.

Los Angeles County Museum of Art, Los Angeles. *Retrospective Exhibition, Georges Rouault, 1953: In Collaboration with the Museum of Modern Art, New York.* Los Angeles: The Museum, 1953. Issue of the *Bulletin* of the Los Angeles County Museum of Art consisting of the catalog of the exhibition held at the museum; exhibition previously held at the Cleveland Museum of Art and the Museum of Modern Art, New York. Supplement to: *Bulletin* (Los Angeles County Museum of Art) vol. 5, no. 3 (summer 1953).

Museum of Modern Art, New York. *Rouault Retrospective Exhibition, 1953.* New York: The Museum, 1953.

Musée Toulouse-Lautrec, Albi. *Exposition Georges Rouault: peintures, gouaches, miserere: du 20 juillet au 30 septembre, 1956.* Albi: Le Musée, 1956.

Perls Galleries, New York. *Georges Rouault (1871–): Nov. 12–Dec. 22, 1956.* New York: The Galleries, 1956.

Musée Cantini, Marseille. *Rouault: 13 juin–1er septembre, 1960, Musée Cantini, Marseille.* Preface by Bernard Dorival. Marseille: Impr. municipale, 1960.

Perls Galleries, New York. *Georges Rouault (1871–1958), the Later Years: Oct. 18–Nov. 26, 1960.* New York: The Galleries, 1960.

Los Angeles County Museum, Los Angeles. *Georges Rouault Prints from the Collection of Harold P. and Jane F. Ullman, November 1–17, 1961.* Los Angeles: The Museum, 1961.

Museum voor Schone Kunsten, Ghent. *Hommage à Georges Rouault.* Text by Georges Chabot. Ghent: Het Museum, 1961.

Galerie Beyeler, Basel. *Georges Rouault: Exposition, janvier–mars, 1962, Galerie Beyeler, Bâle.* Basel: Basler Drucks- und Verlagsanstalt, 1962.

Valley House Gallery, Dallas. *Georges Rouault: Passion. November 15–December 31, 1962.* Text by Robert de Bolli. Dallas: The Gallery, 1962.

Musée de Dieppe. *Georges Rouault: Musée de Dieppe, 22 mai–16 septembre 1963.* Dieppe: Le Musée, 1963.

La Jolla Museum of Art. *Works of Georges Rouault: Paintings and Graphics. La Jolla Museum of Art, September 25 to November 1, 1964.* San Diego: The Museum, 1964.

Musée national d'art moderne, Paris. *Georges Rouault, oeuvres inachevées données à l'État. Musée du Louvre, juin–novembre 1964.* Text by Bernard Dorival. Paris: Ministère d'État, Affaires culturelles, 1964.

Galerie Charpentier, Paris. *Rouault, peintures inconnues ou célèbres.* Text by Raymond Nacenta. Paris: Le Galerie, 1965.

Musée du Québec. *Rouault: Musée du Québec du 28 janvier au 28 février, 1965 [et] Musée d'art contemporain de Montreal du 19 mars au 2 mai, 1965.* Montreal: s.n., 1965.

Arts Council of Great Britain. *Rouault: An Exhibition of Paintings, Drawings, and Documents, Arranged by the Arts Council of Great Britain, in Association with the Edinburgh Festival Society.* London: Arts Council, 1966.

Galerie Creuzevault, Paris. *Rouault, quatorze planches gravées pour "les Fleurs du mal" & XXX lithographies originales, exposition, Galerie Creuzevault . . . Paris, du 25 novembre 1966 au 15 janvier 1967.* Preface by Jacques Guignard. Paris: Le Galerie, 1966.

Frankfurter Kunstverein, Frankfurt. *Georges Rouault. Frankfurter Kunstverein, Steinernes Haus. Adolf und Luisa Haeuser-Stiftung, 12. Februar bis 27. März 1966.* Catalog by Ewald Rathke and Sylvia Rathke-Köhl. Frankfurt am Main: Der Kunstverein, 1966.

London Graphic Art Associates. *Georges Rouault: Graphic Works, 1871–1958.* London: The Associates, 1967.

Galerie Valentien, Stuttgart. *Georges Rouault: Graphik [und] Aquarelle.* Stuttgart: Der Galerie, ca. 1969.

Galerie Beyeler, Basel. *Georges Rouault visionnaire.* Basel: Le Galerie, 1971.

Musée national d'art moderne, Paris. *Georges Rouault: exposition du centenaire. Musée national d'art moderne, 27 mai–27 septembre, 1971.* Catalogue by Michel Hoog. Paris: Réunion des musées nationaux, 1971.

Musée des beaux-arts, Bordeaux. *Hommage à Georges Rouault.* Bordeaux: Le Musée, 1971.

Eskenazi Ltd., London. *Georges Rouault, 1871–1958: Paintings and the Fourteen Aquatints for Les fleurs du mal . . . June 12–July 1st 1972 at Eskenazi Gallery.* Exhibition arranged by Richard Nathanson. London: Eskenazi Ltd., 1972.

University of Notre Dame, Art Gallery. *The Graphic Work of Georges Rouault, January 16–February 27, 1972, Art Gallery, University of Notre Dame.* Notre Dame, Ind.: The Gallery, 1972.

Haus der Kunst, Munich. *G. Rouault, 1871–1958: Haus der Kunst, Munich, 23 March–12 May 1974 [and at the] City Art Gallery, Manchester, 4 June–28 July 1974, organised by the Arts Council of Great Britain in association with Manchester City Art Galleries and the Haus der Kunst, Munich.* Catalog by Bernard Dorival. Manchester: Manchester City Art Galleries; London: Arts Council of Great Britain, 1974.

Yoshii Garo, Tokyo. *Ruō ten zurokū / henshu Yoshii Chōzō = Catalogue de l'exposition Rouault.* Text by Chozo Yoshii. Tokyo: Aporo Bijutsu Shuppan, 1979.

Accademia di Francia a Roma, Rome. *Honoré Daumier, Georges Rouault.* Milan: Electa, 1983.

Josef-Haubrich-Kunsthalle Köln. *Georges Rouault: Stadt Köln, Josef-Haubrich-Kunsthalle, 11. März bis 8. Mai 1983.* Cologne: Der Kunsthalle, 1983.

Museum of Modern Art, Toyama. *Rouault Prints.* Toyama, Japan: The Museum, 1984.

Kunstamt Wedding, Berlin. *Georges Rouault, 1871–1958: Berlin Kunstamt Wedding, Alte Nazarethkirche auf dem Leopoldplatz, 26. Oktober bis 23. November 1988.* Berlin: Das Kunstamt, 1988.

Musée national d'art moderne, Centre Georges Pompidou, Paris. *Rouault: première période, 1903–1920.* Catalog under the direction of Fabrice Hergott. Paris: Le Musée, 1992.

Royal Academy of Arts, London. *Georges Rouault: The Early Years, 1903–1920.* Catalog by Fabrice Hergott and Sarah Whitfield. London: The Academy, 1993.

Salzburger Landessammlungen Rupertinum, Salzburg. *Georges Rouault: Malerei und Graphik.* Text by Stephan Koja. Munich: Prestel, 1993.

Menil Collection, Houston. *Georges Rouault: the Inner Light.* Foreword by Dominique de Menil; essay by Ileana Marcoulesco. Houston: Menil Foundation, 1996.

Musée d'art moderne, Troyes. *Georges Rouault: 6 novembre–15 février 2000, Musée d'art moderne de Troyes.* Troyes: Le Musée, 1999.

MISERERE EXHIBITION CATALOGS & BROCHURES

La galerie des garets, Paris. *La Galerie des garets présente Miserere de Georges Rouault: du 27 novembre au 21 décembre 1948.* Paris: La Galerie, 1948.

Redfern Gallery, London. *Georges Rouault: Original Aquatints for "Miserere" and "Guerre."* London: The Gallery, 1948.

Galerie Günther Franke, Munich. *Miserere.* Introductory text by Kurt Martin. Munich: Die Galerie, 1949.

Kleemann Galleries, New York. *Georges Rouault, Miserere et guerre: 59 aquatints: February 14 to March 5, 1949.* New York: The Galleries, 1949.

Zwemmer Gallery, London. *Miserere: Rouault. Fifty-eight Plates Engraved by the Artist, Zwemmer Gallery, April 17th to May 18th.* London: The Gallery, ca. 1951.

Galerie Louis Carré, Paris. *Le Miserere: cinquante huit planches gravées par Georges Rouault, exposées chez Louis Carré.* Preface by Thierry Maulnier. Paris: La Galerie, 1952.

Museum of Modern Art , New York. *Miserere.* Preface by the artist; introduction by Monroe Wheeler. New York: The Museum, 1952.

Galerie des beaux-arts, Bordeaux. *Les amis de l'art . . . présentent: Le Miserere de G. Rouault; Le prix de la gravure, le Salon des Isopolystes . . . et La rétrospective de Gaëtan Dumas.* Bordeaux: La Galerie, 1953.

Musée national Bézalel, Jerusalem. *Georges Rouault: oeuvres graphiques choisies. "Miserere," 58 eaux-fortes: eaux-fortes en couleurs et des reproductions en facsimile, 11 juin–16 juillet 1955.* Jerusalem: Le Musée, 1955.

Städtische Kunsthalle Recklinghausen. *Otto Pankok, die Passion / George Rouault, Miserere: Städt. Kunsthalle Recklinghausen, vom 6. März bis 8. April 1955.* Recklinghausen: Die Kunsthalle, 1955.

Auckland City Art Gallery. *Rouault: Miserere.* Auckland: The Gallery, 1957.

Galerie Gérald Cramer, Geneva. *Georges Rouault: Miserere: Galerie Gérald Cramer, exposition du mardi 11 juin au mardi 30 juillet 1957.* Geneva: La Galerie, 1957.

Musée des beaux-arts de Rennes. *Le Miserere de Georges Rouault: 11 décembre 1957–26 janvier 1958.* Text by Marie Berhaut. Rennes: Le Musée, 1958.

Palácio Foz, Lisbon. *Exposição o miserere de Georges Rouault.* Lisbon: S.N.I., 1960.

Musées de Metz. *Le Miserere de Georges Rouault: Musées de Metz, été 1965.* Metz : Les Musées, 1965.

Musée d'art moderne, Haifa. *Georges Rouault, Miserere: décembre 1970–janvier, 1971.* Haifa: Le Musée, 1970.

Baltimore Museum of Art. *Georges Rouault: Miserere.* Introduction by Jay McKean Fisher. Baltimore: The Museum, 1977.

Musée des beaux-arts de La Rochelle. *Le Miserere de Georges Rouault.* Text by Bernard Dorival. La Rochelle: Le Musée, 1977.

Musée d'art moderne de la ville de Paris. *Georges Rouault: sur le thème du "Miserere," peintures et lavis inconnus.* Paris: Le Musée, 1978.

Musée de l'oratoire Saint-Joseph, Montreal. *Le Miserere de Georges Rouault.* Text by Bernard Dorival. Montreal: Le Musée, 1979.

Museum of Modern Art, New York. *Rouault, Miserere.* Traveling exhibition directed by Riva Castleman. New York: The Museum, 1979.

Art Gallery of Ontario. *Georges Rouault: Miserere.* Text by Brenda D. Rix. Toronto: The Gallery, 1986.

Centre culturel de l'Yonne. *Rouault: Miserere: gravures, aquarelles, peintures: 30 juin–9 septembre 1990, Collégiale Saint-Lazare, Salle Saint-Pierre, Avallon.* Exhibition organized by Marie-Laure Hergibo. Yonne: Le Centre; Avallon: Musée de l'Avallonnais, 1990.

Städtische Galerie Villingen-Schwenningen. *Georges Rouault: Miserere.* Exhibition organized by August Heuser and Wendelin Renn. Ostfildern-Ruit: G. Hatje, 1998.

Torre viscontea, Lecco. *Rouault: il Miserere.* Contributions by Mauro Corradini, et al. Lecco: Galleria Bellinzona, 2000.

THE MISERERE: EDITIONS, ETC.

Calmel, R.-Th. "Miserere de Rouault." *La France catholique* (11 January 1952).

Getlein, Frank and Dorothy Getlein. *Georges Rouault's Miserere.* Milwaukee: Bruce Pub. Co., 1964.

Lassaigne, Jacques. "Georges Rouault: Miserere." *Graphis* 5 no. 26 (1949): 102–11, 205–6.

Lewis, Virginia. "Misery and War by Rouault." *Carnegie Magazine* 26 (April 1952): 114–16, 129.

Roger-Marx, Claude. "Le Miserere de Rouault." *Gazette des Beaux-Arts* 35 ser. 6 (April 1949): 289–94, 311–12.

Rouault, Georges. *Miserere / George Rouault; cinquante-huit planches gravées par l'artiste.* "Limitée à 425 exemplaires numérotés de 1 à 425 et 25 exemplaires hors commerce de I a XXV." Paris: Édition de L'Étoile filante, 1948.

———. *Miserere.* Foreword by Anthony Blunt. London: Trianon Press, 1950.

———. *Le Miserere de Georges Rouault.* Preface by the artist; introduction by Maurice Morel. Paris: L'Étoile filante; aux Éditions du seuil, 1951.

———. Miserere / Georges Rouault. Munich: Prestel Verlag, 1951.

———. *Miserere*. Preface by the artist; introduction by Anthony Blunt; foreword by Isabelle Rouault. New and enlarged edition. Boston: Boston Book & Art Shop, 1963.

———. *Miserere*. Introduced by Maurice Morel. Assisi: Cittadella, 1966

———. *Miserere*. New edition enlarged with textes [sic] and commentaries. Paris: Editions le Léopard d'or; Tokyo: The Zauho Press, 1991.

———. *Le Miserere de Georges Rouault*. Photographs by Jean-Louis Losi; forewords by Dominique Ponnau and Frédéric Chercheve-Rouault; a previously unpublished contribution by Jacques Maritain; preface by the artist. Paris: Cerf, 2004.

Salmon, André. "Le Miserere de Georges Rouault." *L'Amour de l'Art* 6 no. 4 (April 1925): 182–86.

CREDITS

All images and writings by Georges Rouault:
© 2006 Artists Rights Society (ARS), New York /
ADAGP, Paris

Page 20, figure 1
Courtesy Olson-Larsen Galleries

Page 20, figure 2
Collection of Robert and Sandra Bowden

Page 21, figure 3
Collection of Robert and Sandra Bowden

Page 21, figure 4
Collection of Robert and Sandra Bowden

Page 22, figure 5
Collection of Robert and Sandra Bowden

Page 23, figures 6a & 6b
a) C16533: Bought from Jean Goriany, NY.
Joseph Brooks Fair Fund, 1942.353. Reproduction:
The Art Institute of Chicago
b) C16534: Bought from Jean Goriany, NY. Joseph
Brooks Fair Collection, 1942.354. Reproduction:
The Art Institute of Chicago

Page 29, figure 7
Chrysler Museum of Art, Norfolk, Virginia.
Gift of Walter P. Chrysler, Jr.

Page 29, figure 8
Musée d'Art Moderne de la Ville de Paris.
© PHOTOTEQUE des Musées de la Ville de Paris

Page 30, figure 9
Kunsthaus Zürich

Page 30, figure 10
Musée d'Art Moderne de la Ville de Paris.
© PHOTOTEQUE des Musées de la Ville de Paris

Page 33, figure 11
Kunsthaus Zürich

Page 33, figure 12
Private Collection, London

Page 35, figure 13
Musée d'Art Moderne de la Ville de Paris.
© PHOTOTEQUE des Musées de la Ville de Paris

Page 35, figure 14
Collection Albright-Knox Art Gallery, Buffalo,
New York. Edmund Hayes Fund, 1909

Page 37, figure 15
The Metropolitan Museum of Art. Harris
Brisbane Dick Fund, 1932 [32.113(19)]. Photograph
© 2006 The Metropolitan Museum of Art

Page 38, figure 16
Plate II (page 19) from LES FLEURS DU MAL
by Charles Baudelaire. 1925–1966. Gift of Mlle
Isabelle Rouault. (328.1967.2) The Museum
of Modern Art, New York, NY, U.S.A. Image
© The Museum of Modern Art / Licensed by
SCALA/Art Resource, NY

Page 38, figure 17
Musée d'Art Moderne de la Ville de Paris.
© PHOTOTEQUE des Musées de la Ville de Paris